MY PRIVATE LIFE

MY PRIVATE LIFE

LIFE
Real Experiences of a Dominant Woman

By Mistress Nan

Foreword by Race Bannon
Edited by Joseph Bean

 Daedalus Publishing Company

Published by
Daedalus Publishing Company
2140 Hyperion Ave.
Los Angeles, CA 90027
USA
www.daedaluspublishing.com

Cover, Photo and Design by Steve Diet Goedde

Contact Mistress Nan:
themistressnan@aol.com

ISBN 1-881943-11-9

Library of Congress Catalog Card Number: 94-69814

Printed in the United States of America

Dedicated to my #1 slave, Billy,
who taught me everything and
encouraged me to not do
anything unless I enjoyed it.
If you could only see me now!

And to my wonderful husband
who not only didn't clip my wings,
but taught me to fly...

ACKNOWLEDGEMENTS

There are so many people I would like to thank for giving me inspiration, courage, and incentive to write. Many of them probably don't even know the part they played, but I thank them anyway. However, the two people I want to thank most are my husband and my lover. Without them this book would only be a fantasy.

TABLE OF CONTENTS

EDITOR'S NOTE

I thought I had a pretty good bead on the leather life. After all, I've been in the scene myself since the mid-sixties, I've been writing about it for ten years, reading about it for longer, and lecturing about it almost as long. I ought to know, don't you think, if anyone does? Well, there's knowing, and there's knowing.

No matter how broad your experience of life in all its colors and variations, you see it all from your own point of view. Even when you intentionally expose yourself to another, perhaps very different world view, you are still seeing through your own eyes. If you are (as, in this instance, I am) gay, male, white, into leathersex, a leather Top/Master, middle aged, and living in San Francisco, all these factors and a lot more besides—some of it far more peculiar to yourself—form the lens through which life is visible, the grid by means of which you give it order, the senses by which you determine what is sensible or not, moral or immoral, good or bad, desirable or repugnant.

Then, by the grace of whatever intelligence there is in the Universe that doesn't suffer arrogance comfortably, you run into an opportunity to truly wallow in a point of view you could never have invited yourself into. That's what editing Mistress Nan's book has been for me, not just the chance to see, but a compulsion to look, and to look carefully at another way of playing, another system for valuing SM and conducting a respectable life in leather.

I have made a deal with the aforementioned (Capital I) Intelligence: When I am exposed to anything entirely new to me, I *will* nearly drown in it—as an editor does in the work of an author, for example. I wish I could share

11

exactly that experience with every reader of this book. It would be startling, even life-changing for everyone who is not a mature, married, bisexual, professional woman, and a Dominant. That description includes 99.9% of the people I know, and very likely 99.9% of the people who may ever read this book. I really wish every one of them would read the book with an editor's close eye for sense and mood, tone and motivation.

Yes! This book is worthy of that kind of attention because we all need that kind of "mile in her shoes" experience to grasp a world next door to our own which, for all its nearness, is invisible without an added lens like the one Mistress Nan has to offer.

<div style="text-align: right">

Joseph W. Bean
San Francisco
June, 1994

</div>

FOREWORD

Mistress Nan, the author of this book, is a rare breed of woman. She defies all stereotypes placed upon those people who venture into the erotic world of dominance and submission. While she is a highly respected S/M player, she is also a dedicated wife and mother. While she pursues her erotic pleasures with passion and frequency, she is also a very successful professional. While she is famous within the S/M community's ranks, she is humble about that fame. And, while she certainly pursues her erotic play with expert skill only attainable with her years of experience, she feels no compulsion to mold her kinky persona or appearance to conform to anyone else's standards.

Mistress Nan is a shining example of how one can comfortably fit an active and imaginative erotic life into the necessities of family, loved ones, and professional success. Few would not benefit by learning from her example.

I first met Nan many years ago, and immediately recognized a kindred spirit. Few people exude the kind of passionate interest in dominance and submission that she displayed during that initial conversation. As we talked, I became fascinated with this attractive, well-dressed, articulate, and funny woman who sat across the table. Luckily, that initial conversation has blossomed into a wonderful friendship that I treasure.

With this book, Mistress Nan is giving readers a rare peek inside the world of dominance and submission without the deceptive romanticizing that so often accompanies such tales. True accounts such as these are much more exciting than fiction, at least to me.

As you read these accounts, they may seem so intense

and fantastic as to be impossible except in fiction, but they are, indeed, true. Mistress Nan chooses her partners carefully. In turn, they offer her a style and level of erotic play that proves to be truly satisfying for all concerned. I have spoken with some of the people whose erotic adventures are included in this book, and they all voice unanimous faith in Mistress Nan's skill and ability to bring to life a person's innermost fantasies in a safe and consensual manner.

Mistress Nan's play spans the spectrum from mild mental control to intense S/M scenes. She plays with both sexes. And the facility with which she dons roles to enhance her scenes could elicit jealously from the finest of actors. The accounts in this book can certainly be used as educational material for both the newcomer and the more experienced scene player, but I think their greatest value is that they provide rare glimpses into the personal erotic life of a respected scene player. This can allow the reader to accurately assimilate some of the attitudes, techniques, and scenarios into their own play, which can hardly be done with erotic fiction since it often does not conform to realistic guidelines.

Just as importantly, these accounts serve as erotica of the highest order. If you are reading only for sexual stimulation and excitement, they serve that purpose very well. However, I would caution the neophyte to seek out responsible instructional information about this style of erotic play before attempting such encounters in his or her own life. Safety and consensuality are always foremost, and Mistress Nan would have it no other way.

Enjoy the kinky pleasures of Mistress Nan.

Race Bannon

PREFACE

Can this be true? How exciting. How frightening. I hid
the magazine which had this ad. It was more than I had ever
hoped for. People like me? I sent in my three bucks and
waited. I couldn't believe my luck. Maybe once and for all
I could realize my fantasies.

My life had been full of discipline. I had had more than
my share of spankings. That was the way it was, growing
up in the 40s and 50s in the Bible Belt. However, the
spankings were given as a loving correction, not cruel or
angry punishment. I always knew it was for my own good.
Therefore, it was easy to equate discipline with love very
early in my life. I did not want to be spanked, in fact I
would do just about anything to avoid it. But to hear anyone
else getting spanked, or read about it, or even see the Katz
n' Jammer Kids, or their Mamma, getting spanked in the
Sunday funnies would really turn me on. On Sunday
afternoon I would always masturbate while looking at the
funnies even before I could read.

Radio shows were another good source. Some errant
wife or naughty daughter was occasionally turned over a
knee and soundly spanked, or an adolescent boy was taken

to the woodshed. Periodically, special items would jump out and surprise me: a cartoon, an article about an employer spanking an insubordinate employee, even *Life* magazine had several pictures of Liz Taylor being spanked doing the show "The Taming of the Shrew" (Kiss Me Kate). But the main spanking activity in my life was at our church. Children there were always getting into trouble and would ultimately be turned over a parent's knee and soundly spanked. As I grew into a young lady, I found opportunities to spank. At seventeen years old, I was in a position of authority, and during this period I spanked a couple of young women (they were over 21) over whom I had some authority. I was always terrified of discovery, because I did not have the authority to spank, but the situations were just perfect for discipline. I couldn't pass them by—I took my chances.

One girl threw herself on the floor in front of me and wrapped herself around my legs, begging and pleading for my understanding in this situation. In a disgusted manner I told her she was acting like a child, and she must obey the rules, like everyone else, or suffer the consequences. She continued begging, and I told her if she didn't stop acting like a child, I would treat her like one. Her response was "Yes, anything." With that I took her by the arm and sat down. I pulled her over my knee, raised her skirt, and gave her the soundest spanking I could muster with my hand. She was crying and trying to cover her bottom, but she didn't get off my lap.

There were other occasions which I took advantage of as well. Since we were all raised with the same background, and with very strict parents, spanking was a natural discipline. However, what I thought was unnatural was my

16

reaction after I spanked them: the thrill, the sexual stimulation I felt. It was very confusing.

I was insatiable for reading matter concerning discipline, especially spanking. It was difficult to find anything in ordinary literature, but I did find a romance magazine titled "Mr." that printed a column, "Pats and Peeves." In this column the letters were almost always about spanking. They even asked questions of the centerfold about her spanking experiences and ideas. It was dangerous for me to buy the magazine as I had to go into a liquor store to buy it, making myself vulnerable to discovery. Also, it was difficult for me to hide my reading material at home.

Reading case histories in the library was another option. I knew there were people like me out there, but my problem was how to find them. I was under so much scrutiny in our small town that it was impossible to search for like-minded souls. I was also convinced that people with interests the same as mine would be the degenerates of society. I, of course, didn't fall into that category.

I married, hoping to escape the close scrutiny under which I had lived my entire life, but married life ended up worse. Fortunately, my husband and I relocated to a large city, due to his unemployment, and shortly thereafter (in 1963) I read the ad above. The one which would change my life forever.

I watched the mailbox daily waiting for the key to my adventure. When the magazine came I held it in trembling hands, wondering if I had enough courage to follow through. I read each ad, fantasizing about the possibilities. Over 150 advertisements from men all over the world, who were looking for women just like me: submissives,

dominants, switches. I masturbated thinking about the potential. I knew I would be embarking on an adventure, one that would change me forever. But after writing my answers to three ads, I found I was afraid to mail them. The "what ifs" multiplied. What if I were recognized; what if my husband found out; what if I were injured; what if I were kidnaped; what if I got a disease? I had to be prepared for any eventuality.

I had been overprotected all my life, first by my parents, who scrutinized my every move, then as the wife of a jealous and grossly possessive man who continued my imprisonment. And now, here I was faced with the possibility of exploring my own personal, private need. I had to do this on my own. I thought about it, dreamed about it, lived and relived every eventuality for three months before I finally mailed the letters. My need was far greater than my fear.

I was going about my adventure in a very analytical way. I knew I was interested in the subject of spanking, and I got sexually stimulated thinking of both giving and receiving, so I had to investigate. I answered just three advertisers: One was a man looking for a submissive girl who wanted to be spanked; another, a man who wanted to spank and be spanked in return; the third, a man who wanted to be dominated as well as spanked. Each day I looked at the magazine, and reread my letters. They had to be perfect because I was convinced that each person would be flooded with responses, and mine needed to get their attention. I finally mailed the letters, which included my phone number. I also gave instructions on how and when to call, and what to say in case my husband answered the phone. They all followed my directions.

"Hi, is this Nancy?"

"Yes, it is."

My heart stopped. I knew this was one of the men responding to my letter.

"I just got your letter today and am really anxious to meet you. How about Friday night?" Now, here it was. The door had been opened to my adventure. I talked to him for a while. I wasn't ready to just jump into the car and meet him quite yet. I still had a little common sense, and I was worried. Would he like me? What was he looking for? How do we do this? Is there protocol? I knew I couldn't just go to his house, and he certainly couldn't come here, so we decided to meet at a restaurant and get acquainted. I made no promises except to show up. The other two men I had written to called the next day. I knew I couldn't take too many chances, so I made one date each week. Friday was years away. Friday was in ten minutes. What awful, delicious agony, waiting for my first date.

I was at the restaurant early. Would he come? Was he normal? Would he like me? He was there. He looked like an average person. He didn't look like a degenerate. He seemed normal, he was a dealer at a casino. I'd never met a gambler before. He said all the right things. We were both hesitant to talk in this public place about the secret subject that had brought us together. Neither of us could really eat, and then he told me he had rented a room in the motel across the street. Maybe it would be easier to talk there. He seemed okay. I agreed.

I was so excited my heart was pounding. He was a dominant, and would be spanking me. He did, and it was very exciting. He spanked me on and off for an hour. He never touched me sexually. Even though the action was thrilling, thinking—afterwards—about what I had done and

what could have happened to me, was tremendously frightening.

The second date was not memorable. He wasn't really interested in spanking like I was, so I left as soon as I politely could.

The third date was a bit different. He had charmed me so much on the telephone that I had agreed to have him pick me up from my apartment and take me to his home 30 miles away. And he was due to arrive in an hour. But the more I thought of the dangers, the more I realized how foolish I'd been to make this arrangement. He could be anybody. He could be dangerous, and there I would be, with no one knowing where I was, and with a stranger. I decided I'd better not go through with this. I should just meet him somewhere else. So I left, thinking he would call me later, and we could make other arrangements.

Three hours later I returned to my apartment, and saw a cute little Italian sports car parked in front of my building. That was strange. Then I saw a man wearing a suit sitting out by the pool. That was strange. But I was three hours late for our appointment, so I was sure it wasn't "him." I was wrong.

He was wonderful. We were sitting in his sports car, on the way to his home. He indeed had charmed me. He was a real gentleman. Oh, God! Oh, God, please don't let me be sorry for what I'm doing. I did get a slight reprieve: there would be a stop for dinner before we went to his home.

Dinner was fantastic. I didn't have a clue as to what to order, I had never been in a fancy restaurant before, so I told him to order for me. I'd never had a drink before, and one sip was all I could manage, but he didn't laugh at me. We took a walk on the Boulevard, looking in the windows

before going to his place. He had told me his home was nice, but I'd never seen a place like his. He's a writer. He's a University graduate. He's handsome. He's fascinating. He wants to be spanked. How do I spank a man like this? He's been so charming, so wonderful. He didn't even mention my being so late.

Soon, we were back at his place, sitting on the couch. He'd made a pot of tea and was rubbing my feet. How do I do it? How do I start? To be spanked, somebody must first be bad, to deserve punishment. He didn't. He moved closer, kissing my neck. I held my breath, and with my eyes closed I told him to go upstairs to his bedroom and get ready. He did. I found him lying on his stomach over a pillow, with all his paddles and straps on the bed around him. So I spanked him. I spanked him over my knees with my hand. I spanked him with a strap, a paddle, a hairbrush, then with another strap, another paddle I was in love.

I never wanted to go home again. I had found the candy store. Being the spanker was just what I wanted, it was much more exciting for me than being spanked. And his scene was just like mine. Punishment. Domestic discipline. God! I'm in heaven.

He told me about his friends. He had friends all over the world that were good people in the scene. Within weeks he introduced me to his best friend, Bill, who was into a different scene. His fascination was to be a slave to a dominant woman. I was puzzled because that had nothing to do with spanking, but since my friend was such a wonderful man I was thrilled just to be introduced to his friends, no matter what their scene. After meeting and talking with Bill, I realized his scene was very interesting and exciting to me as well. He gave me books to read which explained more of the slavery scenes. Books to read which I was surprised to

find in print. Gargoyle Press books: *Modern Slaves* and *Presented in Leather*, as well as others with titles like *Tender Bottoms*, *The Merry Order of St. Bridget*, and *Sublime of Flagellation*. I was off and running. I saw Bill frequently as he was on vacation for the month. He told me many stories about scenes he'd done, scenes he wanted to do, and fantasies he had. I began to weave my own scene, and at the end of the month I did the first of many slavery scenes I was to do with him (and others) for the next thirty-two years. It was great. I had two wonderful men in my life, one I was in love with, and the other I loved. And they were best friends. How fabulous, how amazing!

Eventually I married the man of my dreams. The man who beautifully opened up this fascinating, marvelous, sometimes scary world of S/M to me. The man who had waited for over three hours to meet that naive, unsophisticated, girl of three decades ago. And I'm as much in love with him today as ever.

As I look back over my life of the past thirty years, I realize how blessed I am. I have wonderful children, a fantastic husband, and am respected for the work I have done professionally and in the community. Beyond all that I have this fantastic private life that is just as important to me today as it has ever been. Over the years, many people have come into my life. Before the children, came I had three slaves living in our basement. I've rarely been without a live-in slave. I've traveled the world and seen the S/M scene from many perspectives, and from both the top and bottom.

Life *right now* is marvelous as well. For the past twelve years I've had a beautiful female lover who is my slave. Some of the stories here are about Alex. She has taught me—by her own needs and wonderful sense of play—how

to keep the scene fresh and exciting. We've developed our scene together, expanding both of our limits.

Even today, when I think I've done it all, new ideas come up in fantasies or dreams, even in books or movie scenes. These ideas spur my imagination to create new forms of action to develop into our scene. I truly do have the best of all worlds.

On the following pages are personal accounts of my adventures which I've written for my own pleasure. They are scenes I've wanted to remember. There is one scene written for me by Britt, an observer I invited to my lover's fortieth birthday party. He wrote a beautiful account of the scene and I want to share it with you. Another scene was written by my live-in slave of many years. She was so thrilled about the scene, her gift to me was to write this story. The others are snapshots of moments in the Bizarre Private Life of Mistress Nan.

Please remember, even though the scenes seem to be non-consensual, they are not. Consent was given before the actual scene, and all safety measures were taken to insure that there would be no injury to body, life or psyche. Scenes with my lover go further into areas that are new and which may seem non-consensual because they were previously unknown to both of us. We have an understanding and trust that allows this growth. But when expanding limits, it's very important to go very slowly.

I never script a scene in advance—my scenes are always reactionary. I watch the effect my action has on the person I'm playing with, their reaction, and I react to that. I know where I'm starting and usually know where I want to go or what I want to accomplish. However, sometimes I get a reaction that sends me spinning into other areas that I'd never planned to go into. That's my excitement, going into

the unknown. To play with someone whose reactions are honest and true allows me freedom to explore safely. If I find true negative reactions, I change the action. I do not want to lose the sexual edge in a scene, and if I watch carefully, I never have to. That doesn't mean I only do what the person wants me to do. It means, if I do something that is a turn-off, I have a choice: I can either continue doing it, as I know eventually I can turn it around, or I can change the direction. Sometimes I only have to change the approach or the motivation.

I have crossed many boundaries with Alex, and have done every "no-no," but I took my time. When I first met Alex, her absolute "no-no's" were no pain and no ass play. It took me four years before I could spank her, and now she craves it. But it was seven years before I gave her an enema, and now, even though she would like to deny it, it turns her on. Breaking down barriers takes time, care, and some risk. But it can be incredibly rewarding. The enema was something I was not really into. In fact, originally, it had been a turn off. But changing the direction—not using it as a punishment, but as a power-play—allowed it to become an incredible turn-on.

It was the same way with my husband. Although the things I did weren't absolute "no-no's" with him, they were actions he really didn't like. But I liked them, and required that he do them. With time and care, these actions have become important to him, and are as exciting to him today as to me.

To those of you who have such fantasies which, perhaps, have even compelled you to buy this book, *have courage.* Take the journey. There are wonderful people out there just like you. It takes time, strength, and a great sense of adventure. Walk down that yellow brick road, enjoy your

24

fantasies and have fun. Just be intelligent about what you do, and be safe. You can find books and magazines everywhere. Ads from people you can correspond with, talk to, and maybe eventually even play with. You'd be amazed at how many of your friends and neighbors have feelings similar to yours. There are support groups in all major cities, and the primary rules of every group are safety, consensuality, and confidentiality. These groups are there to support you—you're not alone. The first step is the hardest.

A VISITOR

February 1965

The doorbell rang, and I answered in full costume. I knew who was ringing the bell. I opened the door and stood back for him to enter. After closing the door he spoke, "Good afternoon, Mistress."

"Silence! When I want you to speak, I'll tell you!" Before he could recover, I prodded him into the dungeon with my riding crop.

"Stand at attention, arms at your sides, eyes front. Do not look at me."

I lay back on my lounge, and sipped my wine. I spoke in a cold and calculating voice: "So, you think you're good enough to be my slave? We'll soon find out." I picked up my whip, pondering its use while sternly watching the slave.

"At the snap of my fingers you will strip for inspection." I held my fingers as if to snap them, but didn't. Instead, I reached for my drink. I could see his eyes on my hand, and feel the anticipation. He was waiting for the snap. Sitting back on the lounge, I continued to study the slave.

"I think it might be more amusing to watch you strip slowly, one item at a time. Remember, slave, you obey my orders at the snap of my fingers. Remove your shirt." Snap! He quickly removed his shirt, but I was not pleased. "You

27

were a little sluggish. I'm accustomed to being obeyed instantaneously. I think you need a taste of the whip."

I rose slowly, selected a whip, walked over to him and slapped his face. "When your Mistress stands, you will kneel. Kneel, you pig!" He immediately fell to his knees. I slapped his face again as he knelt.

"I didn't snap my fingers . . . why are you kneeling?" He started getting up, I slapped him again. "Who told you to get up?" The confusion went on. No matter what he did, it was wrong.

Putting the handle of the whip under his chin, so that his head was raised and he was looking directly into my eyes, I spoke again, "I think ten lashes with the cat of nine tails might wake you up, slave."

I slowly circled him in anticipation of my delightful chore. "I always enjoy the first time I whip a slave. It takes about two lashes to find out whether you've got yourself a coward, or a so-called brave man. I love the cowards. You can make their flesh crawl just by looking at them. But I like the so-called "tough guys" even better. I love to torture them and watch their alleged masculine dignity slowly disappear as they turn into sniveling, begging wretches. Let's get on with your training. Remember, you are to remain motionless and not utter a sound during your flogging. Is that clear?"

I began to whip him, and then stopped. Waiting, watching him. And, after a suitable stall, I began again, whipping severely to see what he was made of.

"Now slave, you may strip so that I can inspect your nude body." I snapped my fingers. He quickly obeyed, and I ordered him to stand at attention at the foot of my lounge. "Just stay right there, eyes front. At this time you are not allowed to look at me without permission. At other times,

you will be allowed the privilege of enjoying the sight of your Mistress in action."

I slowly rose from my lounge, whip in hand, and began to inspect his naked body. I prodded him here and there with the whip handle while inspecting him as if he were an animal. I didn't miss anything, especially his beautiful erect cock.

"I like muscular slaves. Are your muscles real, or just for looks? I want you down on the floor, and doing some pushups. Show me how good you are." He moved to drop to the floor but quickly stopped himself. "Very good. You're learning."

I snapped my fingers and he dropped.

"I want fifty pushups. Good ones, no cheating or my whip will get to work."

He did as instructed, and quite well. "Now, over on your back. I want some sit-ups." I started whipping his chest, making him do them faster and faster.

"You're pretty good, but not good enough. You'll have to practice for me. I thought a well-built guy like you could do better than this without breaking a sweat. Stand up. (Snap!) Bend over and touch your toes." He bent as I took a breath. "I didn't hear a snap, did you?"

He didn't move, but remained in his bent-over position. "You're getting better, but not good enough. Now stay in that position. It's perfect for punishment."

Picking up a crop, I walked around him and began whipping his ass. His grunts rewarded my efforts.

"Slave, this is nothing yet, it gets worse. Now stay completely still during your whipping. If you move out of position you'll quickly learn what a real whipping feels like. I *will* have control of your every movement. You will learn from the start that I am your Master, to be obeyed.

You will obey any and all orders I might give you. Do you understand?"

"Yes, Mistress, I understand, and I will obey."

"Good. Now drop to your knees." I posed with my fingers ready to snap, but waited for a moment before snapping them. He didn't move.

"I'm getting bored with this finger-snapping. From now on you will obey my words, *immediately.*"

He was on his knees. I selected a dog collar and leash. "Now it's time for the first phase of your obedience training. Down on your hands and knees." Sitting astride him, I fastened the collar around his neck. "All right, take me for a ride."

Using the crop to encourage him, I directed him by pulling his hair this way and that. We toured the house, ending up back in the dungeon. "That was fair. Next time I want a little more spirit."

I stood up and—holding him on a short reign with one hand, and with a whip in the other—taught him to "heel."

"All good slaves are occasionally turned into animals. You are no exception. You will learn to follow me. Keep your head up like a proud dog, but watch my feet. You will stop and sit when I stop, and when I step out you will begin to walk at my pace. Never get ahead of me. Your neck and my ankle should be in line."

I walked a bit before making some sharp turns, jerking his collar to make him conform to my pattern. Whipping him for sloppy turns, for not holding his head up, or for not sitting when I stopped. We walked into the kitchen and over to the dog dish filled with water. "You may have a drink. Yes, that's right. Whenever you need water, you will drink from this dog dish. Now wag your tail. It's such a shame that you don't have a proper tail. Oh, I know how to

remedy that."

I walked him back to the dungeon wall where all my whips hung, and took down a special one. It had only a few tails, but the choice was because of its handle which was shaped like a phallus. Putting a condom over it and lubricating it well I held it in front of his face. "This will make a proper tail, now won't it." I allowed him to view the whip and especially its handle. His eyes became very big, but he didn't say the words which were ready to erupt from his mouth. He was learning control, my control. "Turn around. Now, spread your cheeks. That's right. I want to be able to slip this in easily, so relax your muscles, otherwise it will hurt. That's right. Good. Now make sure it doesn't slip because I would really have to punish you for losing your tail. Let's see you wag your new tail." It was humorous, watching as he learned to properly wag his tail. But he succeeded.

"All right, puppy, you've earned a rest. Curl up around my feet. I know puppies like to lick, so you can use your tongue on my shoes, while you're resting." After a brief rest time, and after my shoes were well cleaned with his tongue, I tugged on his collar and brought him to a sitting position. "You did a pretty good job on my shoes. I think you like high heels. Is that right?"

"Yes, Mistress, I do."

"Lie on your back, flat on the floor."

He did as instructed. I told him to put his head between my feet. I put my feet on his chest, heels on his nipples, then dug my heels in just short of cutting him. He began squirming from the pain. "It doesn't seem that you like my shoes at all. I thought you liked my high heels."

"Ugh . . . Y-yes Mistress, I-I do . . . ugh . . ."

"Well, you have a funny way of showing it."

31

I moved the pressure around his body, then told him to move his body so I could put my heels in his crotch. He seemed to be able to bear the pain in his crotch better than on his chest. His moans were more sexual at this time, and I applied more pressure as his erection grew. "My, my, it seems my slave is having fun."

I then had him move so I could put a heel in his mouth. "Now I want you to suck it like a cock. Yes, that's right." I moved my heel in and out of his mouth, and then slipped my shoe off so he could lick my foot.

"Now, it's time for you to pay for your pleasure. You've been having a good time, so now I want to be entertained. Crawl over here and take this whip." He crawled to me, and I placed the whip in his mouth. "Stand up, and go into the center of the room. Stand at attention with your eyes forward. Now, you will whip yourself for my pleasure. Take the whip in your right hand, swing it around your body in front so that it strikes your back. And make sure you do a good job. Commence!"

He began whipping, testing the swing and where the tails would land, and I then instructed him to swing with full force. After about fifteen lashes I stopped him. "Rather feeble, wouldn't you say? Let's try five more just for the fun if it. And make them twice as hard. I love to hear the leather bite into your flesh. I would be very pleased if you cut yourself with the whip in order to amuse me. Believe me, it would be wise to try. If you don't make a serious effort, I may not let you stop until you do cut yourself. All right, slave, raise the whip. I'm ready to be amused. Begin."

After the third lash I stopped him. "Fetch me a drink so that I can enjoy the sight of your humiliation. And make sure you keep your eyes where they belong." After he

brought the drink, I once again ordered him back into position.

"I forgot the count slave, you will start over." He once again began the whipping. "Turn around so that I may examine your welts." He turned. "Not bad, not bad, but I know you'll do better next time. Oh, yes, you can remove your tail now. In case you haven't noticed, I demand quite a lot of my slaves. In fact I insist on a little more than the human body is capable of. Sounds impossible doesn't it. It's not. That's what whips are for."

I crossed the room and sat on a comfortable chair. "Slave, crawl over here to me and sit at my feet." He did so, then I told him, "Kneel up and extend your arms straight out at shoulder height, as if you were a cross." I put my legs up, using his arms for leg rests. I started with my legs on his arms near his shoulders, then moved them out to his elbows. "Enjoying the view, slave?"

Eventually his arms began to sag. "What is this? You can't support my weight? What an insult!" I picked up a small cat of nine tails and began to whip his crotch. As I whipped him, his cock became erect. "Looks like you're having fun. Well, enjoy yourself while you can."

The doorbell rang. Startled, the slave looked at me for instructions. "Lie down on the floor. Bury your face in the carpet, and keep your eyes closed. If you look up or even peek you will be severely punished."

I went to the door, knowing who my guest was. "Hi, Rene. Come on in."

"Hello, Nan, it's so nice to see you."

"Have a seat."

We exchanged a few pleasantries. The slave, face down on the carpet, had been stepped over, and if he had peeked, he could only have seen this beautiful woman's handmade

33

boots. He had been completely ignored—but we both knew why he was there.

"Rene, would you like a glass of wine?" After her acceptance, I nudged the slave with my foot.

"Slave, listen to me but do not lift your head. You are to keep your eyes down on the floor. If you accidentally look up, I will whip your cock until it feels like it will come off. If you obey, you will be rewarded. You are to get up, go into the bar, pour a glass of red wine, put it on a tray, bring it over, and serve it to my guest. But remember, you are not to turn your back to us. Now be quick!"

"Yes, Mistress."

In a few moments, he had returned, head and eyes properly lowered, knelt down next to Rene and offered her the tray. He had also thoughtfully put a few canapes on the tray. She took the wine and, after sipping, put it back on the tray. Obviously, he would have to stay in that position to hold her wine in readiness.

We talked about our recent party, and the new slave I had sent to see her who was a wonderful craftsman. She told me about the pieces he was making for her. All the while the slave was on his knees in a frozen pose holding the tray. I was proud. After a time I gave the slave instructions.

"Put the tray on the coffee table, and lie down at our feet on your stomach, we need a footstool." He prostrated himself at our feet, and we both put our feet on his waiting body. It was interesting, he offered me his ass and Rene his back or shoulders. He knew my preference. As we talked on and on, the slave was not forgotten, just ignored.

"Poor, stupid slave. You have to lie there like an animal merely because it amuses me. You don't have any fun, do you? Of course, you haven't even seen the beautiful

Mistress Rene. What a pity. You've heard about her for years, and now your opportunity to see her comes, and you have been our footstool. Well, you've been such a good footstool I might let you have one little look—but you'll have to earn it. You must be willing to suffer for the privilege of that one look. Do you wish to see her?"

"Oh, yes Mistress. I would love to."

"Mistress Rene, what do you wish for a payment?"

"Oh, Mistress Nan, I've heard about that fiendish little cage you use on some of your slaves, the one like a bear trap. Maybe he should have to wear that for an hour. What do you think?"

"I like the way you think. Slave, go get the item she's talking about."

The slave got up, keeping his head and eyes down, backed out of the room. Before leaving, he asked if he should put it on himself, or if I would like to do it. I told him to put it on himself, but bring me the lock and key.

"Why, Rene, I forgot all about that piece. I just love it, and am so glad you thought of using it." We laughed and talked. It had been so long since we'd been together to talk, it was refreshing to socialize. Soon the slave returned, in proper attitude, and presented the lock and key to me. Before locking it I checked that the teeth were imbedded into his scrotum. It was delicious as his balls were full due to the activities of the day, and it would get much worse before long.

"All right, slave, now that you are properly dressed, go into the kitchen, and get the champagne and caviar. It's time to indulge." He once again backed out of the room, eyes and head down, and did as he was ordered. After he poured the champagne, I instructed him to kneel on hands and knees to become our table. I placed the silver tray on

his back, and we enjoyed our decadence for over an hour.

"Slave, are you suffering?"

"Yes, Mistress."

"Can you tolerate the bear-trap any longer?"

"Whatever you wish, Mistress."

"Well, I think you've earned a short glance, a moment of ecstasy. Don't you, Mistress Rene?"

"I agree, Mistress Nan."

"Slave, kneel at attention, facing us, keeping your head down and eyes closed. When I snap my fingers you may open your eyes and look up at the beautiful Mistress Rene. However, when I snap my fingers the second time, make sure your head goes down twice as fast as it came up. If I think you looked longer than you should, you will be dismissed for the night. Do you understand?"

"Yes, Mistress, I understand."

I paused for a few moments, snapped my fingers, then after the count of two, I snapped them again, giving him only the shortest of glimpses. He was very obedient, I don't think his eyes had even focused before he closed them again.

"You cheated! How dare you! For your punishment you will assume the *slaves rest* position." He knew the drill—he had to kneel on a dowel eighteen inches from the wall with his hands behind his back, and lean forward until his face was against the wall with the full weight of his body behind it.

"Now slave, you will pay for your insolence. I will tell you when it's time to move."

We laughed.

"Nan, that was quick."

"Well, we certainly don't want to spoil him, do we."

Again we laughed.

"I like his attitude, Nan. Do you ever loan him out?"

We talked for a while more before she left. It had been a great visit. After she left, I walked over to the slave in the corner. "You can come out of the corner now, slave." I had to help him move as his body was stiff. "Go into the bathroom and take a shower. You've been sweating today, and I want you nice and fresh. But don't use any of my towels, just shake the water off like a dog."

While he was gone, I changed into my robe, ready to relax for the night. When he returned, he was still a little damp. "Go ahead, roll around on the carpet and finish drying."

When he finished, I had him stand at attention. "I'm really sexy after today's activities, but I certainly can't have sex with you, it would be like doing it with an animal. Wouldn't it? But of course I can see how talented you are with your tongue. After all, that's what a slave is for: to please his Mistress with his tongue." He was watching me closely. "But you really shouldn't be allowed to start at the top, that would be spoiling you. You should start at the bottom and work your way up. Down on the floor, slave. If you do a good job, I may reward you by letting you kiss my ass."

He was on his knees in a flash. "You'll start with my toes. I'm very particular about the way my toes are sucked. Start with the little toe on my left foot, and work your way across, changing from toe to toe at my signal. I shall indicate my desire for the change my cracking my whip across your back. Make sure you slide smoothly from toe to toe. I don't want to feel any teeth, just eager lips and a willing tongue."

After the fifth or sixth toe, I stopped him. "Stop, slave. I'm not pleased with your efforts. You seem to lack the

proper excitement. You act like you're doing me a favor rather than being granted a rare privilege. Now get some enthusiasm into your actions." He did so, and after I'd had enough of this I told him what to do next.

"You don't deserve it, but you may work your way up my legs to my ass. Don't you dare go any further until instructed."

When ready, I allowed him further. "You may now kiss my ass. But don't you try to sneak your tongue in there."

He didn't.

"All right, slave, I'm in the mood to have my ass licked. Start with long slow strokes and work up the tempo until I can't stand it. If I'm pleased, I might chain you to the foot of my bed. Now get back to work, and don't rush it. Slow and easy."

I enjoyed his tongue action for quite some time before giving him the next order. "Slave, that's enough for now. Open that chest, and get the blanket and pillow. Pull the chains out from under the bed, and fasten the metal cuffs with the padlocks. The ankle cuffs are attached to the bed with a chain long enough so you can reach the bathroom and kitchen. You should be relatively comfortable. And don't worry, I have the keys."

As he settled in, getting comfortable, I warned him: "Make sure you don't keep me awake rattling those chains. In the morning, make me breakfast and bring it to me here in bed. It won't be easy with your wrists locked together, but I know you'll manage. I like breakfast promptly at 8 a.m., so don't oversleep. Goodnight, slave."

"Goodnight, Mistress. I love you."

STRICT MUSIC TEACHER

July 1966

> "Strict music teacher, has few openings for sincere students."

My first ad. Everyone in the scene had ads running in various kinky publications, but we thought it would be interesting to go "mainstream" by using a major newspaper, and see who would answer. I was covered. I was a sincere music student, and could talk music, and if the person were kinky, well that's what I was looking for. However, everyone was afraid of discovery then as S/M was illegal, and could be a very dangerous pastime. So, when I would get calls, I didn't know who was for music and who was wondering if I was kinky.

"H-Hell-lo. I s-s-saw your a-a-d. . . ."

"Yes, are you interested?"

"W-w-ell, uh, I-I was just wondering. . . ."

"Go ahead, don't be afraid to talk."

It was very difficult. I was a little afraid of being set up by a cop or Postal Inspector, and kinky callers, no doubt, were also afraid that this was a set up. I had many hangups and many callers who were probably kinky but thought I was straight. It was, however, better to be safe than sorry.

Nonetheless, I did meet a few interesting people, and had some great scenes.

One person from this period will always stand out in my memory. Richard was a thirty-eight year old man, an attorney who wanted to learn to play the piano. He lived very close to me, and I needed money, so it seemed a perfect job. I had given him several lessons, and he was, as all beginners are, very impatient to play, but didn't want to practice. Many times I would tell him he needed a good spanking because he hadn't practiced. That phrase didn't seem kinky to me as I had said it throughout my life many times, and heard everyone else say the same thing. My mother was always saying "if someone would put her over their knee and give her a good sound spanking, she'd straighten up." Of course, that was in a different culture, so to other ears I'm sure it sounded kinky.

However, one day when I arrived at Richard's house, I found an old-fashioned hairbrush on the piano bench. It looked out of place and for that moment I didn't realize its significance. I picked it up and placed it on a nearby table. I told him to play his assignment, and with trembling hands he attempted, but he was worse than the week before. Somehow, then, at that moment, the fog lifted and I remembered what I had said last week. "Since you'll be on vacation this next week, you won't have any excuse for not practicing, will you? If you don't do a good job I'll just have to take a hairbrush to you."

The hairbrush, of course. I picked it up and said, "Is this why you have the hairbrush out here?"

"I th-thought you meant what you said."

"I certainly did."

And, with shaking hands, I picked up the brush and motioned to him to stand up. "Drop those pants right now,

maybe this will do you some good."

He was fumbling with his zipper, and I noticed that he had a bulge in his pants. It was obvious why he was taking lessons. I was a *strict* music teacher. "Quit dawdling. I want your pants and shorts down right now. Then bend over the bench." I moved the bench away from the piano, and he obeyed. His whole body was trembling.

"Maybe you should have had a good spanking earlier. You've wasted so much time. But from now on I know how to treat you, and if you don't do a good job I will blister your bottom." While speaking I began his spanking. He jumped at each swat. His moans betrayed him. However, I would make this punishment real since I was his teacher, he wouldn't get away with sloppy work or not heeding my warnings. I really got into the scene. After fifteen or twenty swats had reddened his bottom, I allowed him to stand up and dress. I put the piano bench back at the piano and began to play the piece he had attempted to play for me. But I didn't do much better. I found I was shaking so much I couldn't control my fingers, and made a real mess of it all. Fortunately, I don't think he heard me, he was so involved with what had just happened.

There was a marked improvement in Richard's lessons. However, if I didn't spank him one week, the next week's lesson would be terrible. It was obvious he needed to be spanked, but the pride of the teacher in me wanted him to learn. So I devised a chart which he would mark daily when he practiced. If he missed practicing a day, he would be punished. He did excel. He was my only music student for several years, but eventually became so good I couldn't teach him anything more. So I became his supervisor. I would go to his house occasionally to look at his practice chart, and spank him for negligence. The hairbrush was

joined by a razor-strop, and both were kept in the piano bench.

When I would return home after seeing Richard, my husband would say: "He's the happiest man in the world today. You've never talked about the scene, you just do it. You're the teacher, he's the student. The punishment isn't contrived, it's real. He probably doesn't even know you understand the scene, he just thinks you're a *strict music teacher*"

SHOE SALESMAN

April 1977

I always bought my shoes in New York City, at I. Miller. I usually had the same salesman, who knew I liked to try all the styles. He also knew he would have a good commission, as I always purchased eight to ten pairs of shoes at a time, and had them sent to my home.

Once, when I walked into the store, he shoved aside the other salesmen who were waiting their turn, to lead me to a sofa. He mumbled a cursory, "She's my customer," to their startled faces, and greeted me warmly. He asked if he could get me a glass of fresh squeezed orange juice, or cup of coffee.

"Thanks, but no thanks today. I'm in a real hurry. I'll come in another day, but today I just need a plain pair of high heeled pumps, black of course. I can't believe that I forgot to pack them, I have so many at home."

"No problem, Mrs. D—, I'll be just a minute." He didn't need to ask my size. He disappeared into the stacks. But when he returned he had several boxes. I was really in a hurry, and didn't want to see anything else. He opened the first box.

"These are perfect," I said as he carefully put them on my feet. I once again noticed just how carefully he put the shoe into his crotch while squatting in front of me, and after

my heel was well placed in the shoe, both of his hands did an imaginary smoothing of the shoes up my leg while never touching me. This was the first time I'd really noticed that, but I did seem to remember the action. It was as familiar to me as he was.

"How do they feel? They certainly look wonderful on you. Why don't you walk across the room to the big mirror?"

I did as requested, and came back quickly. "They'll do just fine. Here's the money."

"Mrs. D—, I have these others I know you'd love."

"Not today, I'm really in a rush, but I will be back tomorrow. I don't want these sent, I need them for tonight."

He came back with my change. "Can I deliver them for you?"

Deliver? He'd never offered before, but then I'd always had them sent. "That would be great. I'm at the Plaza, room 207," I told him on my way out.

"B-but when will you be there?"

Automatically, I responded that I would return at one p.m. I didn't really think to wonder why he was asking the question. At one o'clock I returned to my room. Shortly after, there was a knock at the door. When I opened the door, I saw my shoe salesman standing there with a shopping bag. I moved to take it from him when he asked me if he could come in.

"I have something else here that I want you to see."

"All right, come on in." I quickly sat on the nearby chair, wanting to get this over with as I was a bit uncomfortable. He took the black pumps out of the box, and once again knelt in front of me, holding the first shoe in his crotch as he had done at the store. And, once again, after

my heel was placed in the shoe, both hands did an imaginary smoothing up my leg without touching me. I immediately understood the gesture. He placed the other shoe on my foot with the same action. I stood up, and walked across the room.

"Yes, these are fine, but what is it you have to show me?" I asked rather impatiently. He reached back into the bag and gently removed another box.

"I've been saving these shoes for you. They are the most beautiful shoes I've ever seen, and I've wanted to see you wearing them." With that he removed a pair of black, sling-back, snake skin pumps that were trimmed with gold. "By the way, the trim is 14 karat gold."

I sat back down. After removing my plain pumps, he once again lovingly placed these precious shoes on my feet. This time his hands—as gently as butterfly wings—briefly touched my stockinged legs while smoothing the imaginary wrinkles out of them. I knew!

I stood up in front of him and walked across the room. They indeed were delicious, and felt wonderful on my feet. I watched him. His eyes were riveted to my feet, and I knew. I walked back over to him, sat, and put my foot up to his chest. He looked at me, and I looked at him. Without a word spoken he lifted my foot to his lips and kissed it. He kissed the instep, the open toes, the heel, and rubbed them against his face. I looked at his crotch. I placed my other foot, not too gently in his bulging crotch and pushed. He groaned. I stood up and pushed him over onto his back, putting my foot on his neck.

"Is this the way you deliver shoes to all your customers?"

He didn't answer. I walked around him and told him to crawl over to me as I moved to the sofa. He obeyed. I had

45

him lie on his back so I could put my foot on his face with the high heel in his mouth. "Suck that heel you worm."

Eventually the shoes came off as did his trousers. I put both shoes into his Jockey shorts with the heels pressing into his scrotum while my bare foot was pressing down hard keeping them in place. He was licking my other foot, trying to devour it while sucking my toes through my nylons. "It's time for you to go now. I'll see you tomorrow at the store. Put my shoes back in the boxes. Thank you."

He left a little more meekly than he'd arrived, and without the gold-trimmed, snake skin shoes.

A NEW JOB

August 1973

"You seem like a nice young man, and your letters of recommendation are good. Your former employer, Mrs. Volt, said you had integrity, which is of utmost importance. Hmm. I see that she sometimes had to keep an eye on you as you had a tendency to be a little lazy on occasion, but your work was usually quite good. Is that true?"

"Yes Ma'am, I guess I can be a little lazy, but I assure you, I will really work hard if you give me this job, Mrs. D—. I'll really try to do a good job. If you don't like how I do something, just tell me. You only have to tell me once, really."

I noticed he blushed a bit and cast his eyes down when I questioned him. But he was very pleasant and seemed willing to work, and I needed someone quickly. He had a pleasant attitude and demeanor as well, and could start immediately. "All right Jim, you seem to be the type of young man that could fit into our family quite well. You have a good attitude, you have a nice appearance, and seem to be willing. However, there are some things you should know about me and my family before you accept the position. I am a very strict woman. I do not tolerate laziness nor neglect. I will oversee everything you do, and if it does not meet with my approval, you will have to do it again. I

will not abide bad attitudes or a bad disposition. If I find your work is consistently below my standards, or that you have a bad attitude, you will be punished."

"Punished? Ma'am?"

"Yes, Punished!"

"What do you mean? What kind of punishment?"

"I use the cane."

"The cane, Ma'am? You mean a walking stick?"

"No, (I smiled) heavens, no! That isn't a punishment instrument. I mean a rattan cane like they use in England to punish children."

"I guess I'm not familiar with English punishments. I've never seen a cane. Does it hurt?"

"Yes, indeed it does. That's why usually *six-of-the-best* is all that's necessary for a punishment to be successful."

"Oh! That must hurt terribly."

"Well, Jim, it does hurt, but only enough to insure you do a better job. It doesn't harm you. In fact, it only leaves you with a stinging bottom. If children can handle being caned, a big young man like you surely wouldn't have a problem. However, if your work is good, there isn't any reason you should ever be punished, so you shouldn't worry."

During this little exchange I realized he hadn't rejected the punishment. He was only questioning it, and that was positive for me. Now it was time to test him.

"Jim, to clear up any misconceptions, I think we should have a little experiment. I will give you a couple cuts with the cane so you can judge for yourself how bad it is, and I can make certain you are the type of person I really feel will fit into our household."

He was really nervous now—fidgeting, eyes darting around the room, and having difficulty responding. "Oh, I

don't know. As you say, if I'm really good I shouldn't have to worry about being punished at all. And I think I can really be good and obedient, Mrs. D—."

I smiled. He had accepted already, but just didn't know it.

"Jim, were you ever spanked by your parents?"

"No, Ma'am," he stuttered, "I wasn't."

"Well, that is even more reason that you should feel the cane. You don't have any experience in being punished. Do you? And I think before I accept you into my employ, I need to see your reactions—and you do need to know what it is that is hanging over your head, so to speak." While saying all this, I got up and went to the front-hall closet, opened the door, and removed the cane from the hook. I turned to him, lightly tapping the cane on my left palm.

"I . . .I don't . . .really . . .uhh, d-don't think it's necessary, Ma'am. I'll really be good. Oh! That looks . . . Oh, my"

His eyes were riveted on the thin cane. "All right, Jim, do you really want this job?"

"Yes, Ma'am, I really do, but"

"No, there are *no buts* about it. If you are going to work for me, it is necessary for you to feel the effects of the cane before we go any further. Now, stand up and come over here." I stood and pointed to the end of the couch. He complied, although rather hesitantly. "Good, now, Jim, drop your pants."

"W-what?" He looked at me with surprise.

"You heard what I said. Now drop your pants. All punishment is done on the *bare* in this house, and you are no exception. Drop your pants and bend over the end of the couch, with your bottom in the air."

His hands shook as he went over the options he had at

49

this moment. He could just leave and forget this incident, and me with my cane, or he could submit to me this once and leave knowing he could do a really good job and never have to go through this embarrassment again—and earn more money than any of his friends at college. What would it be? His hands fumbled with his zipper, and we both knew the answer.

"Now stand right there. Yes, and bend over. Yes, and fold your arms under your head. Make sure you're comfortable, or as comfortable as this position will allow. That's right."

I stood back, and touched his bared bottom with the tip of my cane. He jumped. "It's all right, Jim. Just relax. I'm just taking aim. I don't want to miss, so just stay still. Keep that bottom up in the air, and don't move. You will receive three strokes today. This is not a punishment, this is a test. There is no way to sufficiently warn you about the feeling of the cane, so the first stroke will be an easy one. But *do not* get out of position until I tell you to stand up. Do *not* put your hands back to cover your bottom. You may cry out, but try not to be too loud as you don't want my children to hear you and come in to see what is happening, now do you?"

"No, Ma'am. Oh, please. . . I've never"

"All right, ready, now."

Crack! He jumped up clasping both hands to his bottom.

"Now, Jim, what did I tell you? You just disobeyed me." Startled, he looked at me like I was speaking a different language.

"What? What did you say?"

"You heard me. You just stood up, and are rubbing your bottom, and I told you to stay in place and to not touch your bottom. Is there something wrong with your hearing?"

"Oh, no, Ma'am. I just didn't realize It hurt so much I'm sorry, er, I"

"Well, then, get back in position, and we'll start again. I won't count that against you this time."

"What? What do you mean?"

"Just what I said, Jim. Get back into position, and we'll just forget all about that little indiscretion, this time. I'll just start over and give you three strokes as we agreed upon. You will be no worse for the wear, and you'll have a very good job." He hesitated. Was it really worth it? Could he take this? What kind of woman is Mrs. D—? Well, he must have thought, $10.00 an hour for an otherwise cushy job. In any case, he got back into position.

"Please, Ma'am, I'm sorry, but that was hard. I'm not used to anything like that. It really hurt!"

"Yes, Jim. I told you it would hurt. But don't be a baby about this. Children have been caned, even the very young, and they don't make as much fuss about it as you are making. Now, just fold your arms under your head, keep your bottom in the air, well presented, and we'll get on with it. Remember, don't move out of position. Are you ready?"

"I guess so." His white bottom accentuated the red line that was brightening by the moment.

"Okay." S-s-s-s-s-w-w-w-ish crack!

"E-e-e-o-o-o-w-ww-e-e-e"

"Remember, keep those hands out of the way. Good. Much better, Jim. That was one."

"Oh, my God, Ma'am, it hurts."

"Yes, it does, and you only have two more." I stood waiting for the wave of pain to subside, and watched as the double-tracked line started taking color. Within seconds it was turning red. I tapped his bottom again with the cane.

"Remember, you don't want to alert anyone, so keep your voice down. Ready?"

Tap, tap, tap, then s-s-s-w-ish crack!

"E-E-o-o-o-o-w-w-w-w. S-s-s-s-s." He had remembered to put his face into the cushion of the couch to muffle much of the sound. His arms had come unfolded, he placed his hands on the arm of the couch as if he were going to push off the couch, but he just stayed that way. He didn't stand up, and didn't cover his bottom. I was impressed.

"Only one more, Jim. You're doing fine. Just think, this may be the only time you ever see this position. It's up to you. If you do a good job, you'll never have to be punished. Now, this last one is going to be a real stinger."

"What!? I mean, the others were real stingers. I can't possibly take them any harder, Ma'am. Really, I couldn't. I'm going to work really hard, you'll see. I really will, Ma'am."

"Get back into position, now, Jim. That's right. Arms under your head. Just one more. Just one. Now get that bottom up, put your back down. Bottom up. That's right. Just one more." I took my time. This was the last one, and it would be a good one. I didn't want to miss my mark, this one would be at the bottom of his bottom, where his shorts were tightest, and would bother him the most later when he was sitting. This was my favorite spot to hit. It hurt most and lasted longest.

"That's good, Jim. Attention!"

S-S-S-S-W-W-W-W-I-S-H C-R-A-C-K! ! ! !

"O-o-o-o-w-w-w-w!"

His hands clasped his bottom and he was on his feet jumping around the room in a comic manner, panting.

"Oh, oh, oh, that *hurt*! Ow, ow. Oh, my God."

Smiling, I watched his antics. "Yes, Jim! Now you really

know what a caning feels like. That last stroke was a real *one-of-the-best* stroke. I want you to remember that stroke, Jim. Yes, remember that stroke. If I ever have to punish you, *that* will be the kind of strokes you will receive. Enough of your clowning, it wasn't that bad. Now pull up your pants and put yourself in order. And, by the way, comb your hair."

He gently pulled his shorts up, being careful to tenderly cover his bottom. "Believe, me, Ma'am. I'm never going to do anything that will displease you. Please, just say something to me if you aren't completely happy. I'll do whatever you say. I really will. I mean it. I'll be very obedient."

He was babbling. "Jim, stop! Are you ready to go to work?"

"Now?"

"Of course, now."

"Sure, sure, I guess I could start today"

"Fine, then come into my office, and I'll show you what I need to have done."

I replaced the cane on its hook in the closet, watching Jim out of the corner of my eye. His eyes never left the cane. It seemed to me that a breath of relief came out of him after I closed the closet door. He followed me into my office.

"See the papers here in this bin? I need to have them filed. The top bin is for my professional papers, the second is for financial, the third personal. I've put post-it notes on each paper so you'll know the name on the file. Every day that will be your first job. When that is done, open the mail and sort it. Make four piles: personal, professional, checks and advertisements. You will put Mr. D's mail on that table. If there is any mail for the children, put it in their

rooms, and put all magazines in this basket. When sorting the mail it is *very important* to keep the envelopes. Open the letter and staple the envelope to the back, just like these. Do you understand?"

"Yes, I think so. Where do you want me to put the piles after I sort the mail?"

"Right here on my desk. Any other questions?"

We spoke for a few minutes about the routine I expected, the time he would be here each morning, how many hours, and other things he could do for me. He listened and asked appropriate questions. I told him when he was finished with the paperwork to come into the kitchen for lunch. I would have his next jobs ready then.

The day continued beautifully. The children liked him. He was young enough to interact with them, yet old enough to command their respect. He had already won my son over when he said he played Dungeons & Dragons occasionally. My daughter was enthralled when she found out he loved to skate on the boardwalk, and would be happy to take her with him when I would permit it. And, even better, he would help them with their homework, if I would allow it. All in all, I felt I had found the right person to work in my home.

Days and even weeks went by more or less uneventfully. There had been a few mistakes, but nothing terribly important, and nothing had to be corrected twice. Jim became part of the family and was indeed easy to be around. He was helpful, courteous, diligent, and even a good cook. However, one day I was responding to a letter I had received, and when I needed the address I looked for the envelope which would be stapled to the back of the letter, and it wasn't there. I called Jim into my office and asked him where the envelope was. Alarmed, he began

searching, but did not find it.

"Jim, haven't I told you before about the importance of stapling the envelope to the letter, just for this reason?"

"Yes, Ma'am, you did. And I can almost swear that I did staple it. I just don't know where it is. I'm really sorry, I don't know what happened."

"I'm sure you are sorry, but this is the second time I've had to reprimand you for this same reason. Do you remember what happens when I have to tell you something twice?"

"Oh, no, please"

"No whining, Jim. Go to my closet and get the cane."

"Oh, Ma'am, I'm really sorry. Please, don't cane me. I'll find the address. I'll get it for you. Please, you don't need to cane me. I'll never forget again."

"Really, Jim, that's enough. Now go and get the cane before you make it worse for yourself. At this point I'm only caning you for neglect, don't make it for resisting my authority also. Just go get the cane. Now!"

With that he left the room. I wasn't sure if I saw a little resentment in his attitude or not, but for the moment I would just continue as though I hadn't. His attitude, when he returned to the room, cane in hand, was different. He was once again amiable as I had grown to expect him to be. I took the cane from him and ordered him to clear off the desk, which he did quickly.

"Drop your pants, Jim, and bend over the desk, grasping the other side. That's right. Now bottom up. You do understand why you are being caned, don't you?"

"Yes, Ma'am. I was negligent."

"I'm glad you understand. It's very important that you know the reason for the punishment, otherwise it does no good. I realize you didn't do it on purpose, but whether

done on purpose or not, the result is the same. I don't have the information I need at my fingertips, and for that you will be punished."

"No, Ma'am, I didn't do it on purpose. Not at all. Please, please not too hard."

I began tapping his bottom while speaking, and noticed his whole body was trembling. He was grasping and releasing the desk. His knuckles were white, he was crossing and uncrossing his ankles. "Jim, spread your feet apart. That's it. Fine. Hold your bottom up for the cane. Yes, that's it. Now remember, you must stay in position until I allow you to get up." He said nothing. "I didn't hear you."

"Yes, Ma'am."

"You will receive *six-of-the-best* for this punishment. I hope that six will be enough for you to not repeat the incident."

"Yes, Ma'am, it will."

"And remember, no loud crying out. I don't want to alert the household. Do you?"

"No, Ma'am, I don't."

S-s-s-w-w-w-i-s-h c-r-a-c-k!

"U-u-h-m-m-m. Oh. Oh!"

"Good, you stayed in place. That's very important because if you get out of place this time we begin again. Do you understand?"

"Yes, Ma'am."

I walked around him while speaking. Once again I began with tapping, then s-s-w-w-w-i-s-h c-r-a-c-k! "Ugh. Oh. Ow. Oh, please, I'll be good."

"Oh, I know you'll be good. You'll be better than ever. I think I know you by now, you'll probably be good for another two weeks, and when the memory of this caning has

56

faded along with the marks, you will become neglectful again. Is that so?" I was tapping again, showing him where the next mark would be placed.

"Oh, no, Ma'am. You'll see, I'll be better than ever. I won't ever forget this. No, really I won't."

S-s-s-w-w-w-i-s-h c-r-a-c-k!

"Aaiiiee, Ow! (He was sobbing.) I'm truly sorry, Ma'am. Oh, please forget the rest. Please?"

"Forget the rest? You've only had three. Now stop being such a baby. You will get *six-of-the-best* just as the others in the household do when they disobey, and let's have no more of your sniveling."

S-s-s-w-w-w-i-s-h c-r-a-c-k!

His hand immediately went to cover his cries. I didn't have to make the strokes harder. The cumulative effect was making it more difficult with each stroke. "How many strokes was that, Jim?"

"Uhm. Oh, I. . . I'm not sure, Ma'am."

"I'm sure you know. Now just think."

"F-four, I think, Ma'am. Was it four?"

"See, I knew you would know how many. Of course it was four. Only two more to go."

I walked over to his bottom and stroked it with my hand. "Your poor little bottom. It's got red lines all over it. Four very bright red lines, and they won't go away quickly. Now you are to have two more, and I don't want any further nonsense. I smacked him a couple times with my hand. "These two will be hard, and then it will be over, and you will go back into the bathroom, refresh yourself, and then go fix lunch for us. Do you understand?"

"Yes, Ma'am, I do."

"All right. Attention, Jim."

S-s-s-w-w-w-i-s-h c-r-a-c-k!

There was a very delayed reaction to this stroke, but eventually I heard the muffled moans. "Please, Ma'am. I know I can't get out of the last one, but I really want you to know I'm sorry. I never want to disappoint you again."

"Good, Jim, I understand, and I appreciate it. Now, get ready for the last stroke, it will be the best."

I tapped and waited, he quivered and waited. I wanted to draw out the final stroke to make it worse both mentally and physically. I once again aimed for the bottom of his bottom—that sweet, natural line at the base of the buttocks, where bottom and thigh meet.

S-S-S-W-W-W-I-S-H C-R-R-A-A-C-K !

His held breath came rushing out of him as though he'd had the Heimlich Maneuver used on him. Then, in a moment, the sobs came. He collapsed across the desk, sobbing. Not only from the pain, but from the punishment and his desire to please. I put the cane down and drew him into my arms. He gripped me like a lifeline, and I held him until a little composure had returned.

"You took that quite well, Jim, and I'm sure you won't need a repeat performance."

"No, Ma'am. I really don't want to displease you. I hope you know that."

"Yes, I believe I do know that. And now you had better go into the bathroom and wash your face and comb your hair. You have lunch to prepare."

A Surprise!

June 27, 1980

*This is an account of a scene I had with my slave,
described from her viewpoint. She wrote this in thanks
for the special scene.*

I was told to prepare myself for a scene today. It had
been four months since our last major scene. I was both
frightened and excited by the prospect of what was to come.
As the day wore on, my Mistress and I became engrossed
in back paper work and reestablishing the household
routine. I had been out of town for three months, and
getting organized was a priority, so I gave up any hope of
the scene.

At 6 o'clock all work suddenly ceased, and I was told to
shower, then go into my room, naked, sit down and wait.
I did as I was told. A few minutes later my owner came in,
sat down, and instructed me to find my white corset. I did
as instructed. I clipped the corset in front, and backed up to
her. Silently, she laced the corset tightly. She surveyed her
handiwork, nodded with approval and instructed me to find
an appropriate pair of pumps. I started to ask what was to
go over the corset. The question was anticipated. Without
a motion she said, "Take your black cape out of the closet."

I reached in and handed it to her. I could feel it going over my shoulders, but then it was removed and dropped over the chair. I turned to find out why, and found flex-cuffs in her hands. (These are self-locking, nylon strips used in place of handcuffs by riot police.) They were quickly bound around my wrists. With my hands secured behind me, the cape was repositioned and we headed for her car.

I wasn't sure if I should ask questions. My better judgment won out over my curiosity, and I kept silent. As the car cruised east on the freeway, I became more attentive. This wasn't her normal route to the dungeon. When she passed the next freeway junction, and changed to a northbound freeway, I was even more perplexed. From the time I went into my room until now, not ten words had passed between us.

I watched familiar scenery go by. First the 9th Street exit, then 6th Street. At 3rd Street, she turned and took the winding ramp down. For the life of me I couldn't figure out where she was going. Somewhere around Hill Street she made a series of left and right turns. I don't know if they were necessary or if they were done to confuse me. Even if confusing me was not the object, it was indeed the outcome. I was no longer sure of where I was.

The car turned into an almost empty parking lot. It was still daylight, but there was very little traffic on the street. She stopped the car and got out. I wanted to ask for instructions, but held back. Her mood now frightened me. She walked around the front of the car, opened my door, and pulled me out. I stood there, regaining my footing. Without a word, she got in the car and drove off. I watched the car kick up a little dust and stone as it circled around me on its way back to the gate. She turned into the street

and was gone.

"I don't believe this," I said to myself as I started to walk toward the gate, feeling very vulnerable with my hands cuffed behind me. I had taken three or four steps when someone came up from behind. I started to turn and look.

"Your Mistress sent me." It was a male voice.

He put his hands around my elbows and started to gently propel me forward. I tried to turn around. The voice said "don't."

We entered a four or five story building next to the empty lot. The long hallway echoed with the sound of our footsteps. The sound was ominous and annoying. We entered an old-fashioned elevator. I was turned to face the corner. The gate creaked, then banged shut with a metallic thud. I tried desperately to catch a glimpse of my keeper. For a brief second I saw him, he was unfamiliar.

The elevator jerked to a stop. Its rusting gate opened, and we got out. We walked a 20-yard hallway. The barrier at its end was opened. He steered me forward and into what looked like a large, almost cavernous room. My eyes began to adjust to the light, or lack of it. I thought for a moment that I heard voices around me, whispers, really. They promptly ceased. I was nudged forward, then to the left. In front of me was a very large chair surrounded by candles and pillars, or at least what I thought were pillars. It was hard to make them out in the dimness. At first I thought I was in an old parking garage, but then I realized it could be any loft or basement in Los Angeles. The hands that had been my guides were gone, and I was left standing alone.

"Slave" the voice was familiar, thank God.

As the chair turned around, I breathed a sigh of relief. My owner was sitting there. Everything up till now had

been so uncharacteristic of her that it was truly a relief to find her in that chair. "Kneel!" Muscle memory bent my knees but my brain was startled by the tone of the voice that commanded. She was cold and distant. The command was given in an imperious tone I had often heard directed at others, but it was rarely used with me.

I felt someone remove the cape, but I still didn't have the use of my hands. I could see her eyes in the dimness. There was a distance between us that I was unaccustomed to. For the first time, this situation truly frightened me. "You're going to be the centerpiece for our little games tonight." She leaned toward me, put her hand under my chin, and lifted my head. The word "games" only added to my discomfort. "Some friends of mine are here to watch me enjoy you."

I was hoping to see some sign of her mood in her eyes, but there was nothing there I could interpret. I felt hands behind me. The flex-cuffs were removed. "Kneel up!" I obeyed. She stood and began to walk around me. On instinct I lowered my eyes and followed her by the scent of her perfume. I could hear the heels of her boots clicking against the smooth floor. She began to speak again, but not to me. I couldn't hear all of what she was saying: "This is my property. I can do anything to *it* that I choose."

How many people were in the room, if anyone? Was she just trying to make me nervous? Was I really going to be the centerpiece for some sort of games? My mind was brought back to the moment when I heard the command, "Lean forward." I bent at the waist and put my hands and my face against the hard cement floor. Its coolness against my face was a relief.

"That's enough!" I froze where I was.

Softer footsteps came out of nowhere. The hands that

came with those footsteps shackled my wrists, then attached the shackle chains to a ring in the floor. The action was repeated on my ankles, I assumed it was done by the same hands. "Release her ankles." One leg was unshackled, and my legs were kicked apart. The shackles were reapplied then secured properly to the floor. I was spread completely. The coolness of the night air made me realize just how red I had turned, how vulnerable I was feeling, and how obscene a position I was in. Now I couldn't watch. Whatever pleasure I might have felt and whatever security I might have gained from being able to see my Mistress had now been removed because of the position. Of all the things that might go on tonight what had just happened was the worst.

She spoke again to whoever was there with us, and then I heard a swish, and felt an all too familiar explosion on the back of my thighs. It wasn't as severe as it could have been. Before I could take in a deep breath, I was struck again. Not too hard, but definitely hard enough to hurt. The cane strokes were repeated again and again, up and down my thighs and across the bottom of my buttocks. They were random, coming from different directions, landing at different angles. Each stroke got stronger, and the cumulative effect was devastating. Finally it stopped. For the first time, I would swear, in minutes, I breathed again.

I realized there were other sounds around me. Other people were breathing too, laughing, talking. When my own heart stopped pounding in my ears, I could hear conversations. I couldn't find my Mistress. All I could see and feel was concrete. I was connected by a white-hot leash of pain to her thoughts and actions.

"I love to see you in pain. It feeds me. It delights me. I do it because I can." She punctuated her remark with a

heavy cut from the cane, then dropped the instrument at my head. The sound echoed in my ears. "Release her hands and pull her forward." I lay against the now-warm floor, stretched into something like a human Y. My hands were barely secured to the floor when a whip came crashing down on my buttocks. I couldn't hold my sounds anymore. I started to scream.

"Scream all you want to, no one outside will hear you and no one in this room will come to your rescue." Her words were punctuated by the continuous slaps of the toy she was using, not just against my buttocks, but against the tops of my thighs, my ribs, my back, and shoulders . . . anywhere, it didn't matter. That whip was landing everywhere. My attempts to turn over were thwarted. There was so little slack in the chains that held me, all I could do was wiggle. Perhaps to show her power, she brought her foot down against my waist and held me in position while she continued to swing that dammed whip.

I didn't want to cry, especially because I didn't know who was watching. And the thought of my body beginning to heave with tears brought me back to the reality that there *were* other people there. The whipping continued, and continued, and continued until I thought that there wasn't a square inch of skin that she hadn't hit, flogged, beaten. I hate the taste of my own tears, and yet their presence on my face indicated that my body and my will were beginning to bend to the will of She who owned me. The whipping stopped. I was sighing, almost sobbing, in the little pool of water that had formed between my face and the cement. I desperately wanted to see her, but all I got were her boots circling around me. My pain made her voice sound distant and muffled.

Now a new horror was being applied to my already

welted flesh. Sticks, switches, birches? I could feel the new
instrument cutting lines into the tender welts. Twenty,
perhaps thirty strokes later she stopped. There was a sound
of footsteps and of metal scraping against the floor, as
someone brought over the chair that she had been sitting in.
It was set down just out of my limited visual range. Next
came the sounds of a body being seated. Her voice was
closer now, as was the scent of her perfume. Perhaps now
that she was sitting down I would get a rest. A hand began
to stroke me. I hoped it would be a reassuring, gentle
touch, but it wasn't.

"Look at these welts. Her skin is opening up here and
there." The hand was checking its handiwork, noting the
welts, tracing a few of the cuts, following the cane's marks.
She was pointing out different marks and cuts to some of
her guests. She checked the insides of my thighs, and I
guess she wasn't pleased. The object in her hand began
again in earnest down the insides of my thighs, against my
labia, into all my vulnerable spots. I could feel bits and
pieces of it breaking off in and against my skin. I knew I
was screaming so loudly I would soon go hoarse. Something
cotton and faintly human-scented was put in my mouth.

The corset, the only little bit of protection I had, was
now being unlaced. I could feel her hands opening my scant
amour. In just a few moments it was completely free, and
left underneath me. I was totally exposed. The whipping
began again. The cotton muffled my screams and absorbed
my tears. I bit down, gratefully, perhaps I could stifle the
sounds that I did not want to have escaping my lips. She
was laughing, joking with others, as she continued the
torrent that was rendering me quickly both physically and
emotionally useless. That goal was achieved. I was a
sobbing, basket-case of pain.

"She marks so beautifully Yes, it can be tiring, but look, isn't it worth all the trouble?" I could hear her voice again through my tears, and I tried desperately to focus on it, hoping that it would block out a little bit of the flood of screaming sensations coursing through my flesh. It didn't, it only made the situation worse.

For a few moments there was nothing. As my eyes began to clear, I blinked away the last of the tears and focused again. There were feet around me. I couldn't tell how many pair, or if they were male or female, and I didn't have the strength to lift my head to follow them to their natural conclusion. I heard the sound of a table being carried past me, and I heard it being set down, close, probably beside Madams' chair. She said "thank you" to someone. Then put her feet up on my back. Part of my submissive being loved the gesture, but the masochist in me cringed at the feeling of her heals digging into my skin. I felt something. She was pouring something on me, probably what she had been drinking. My nose was far too blocked up to be able to understand the aroma. I'd even lost the scent of "Private Collection," my Mistress' perfume. All I could smell were my own tears.

I heard her again, that voice, that hard cold familiar voice telling me and everyone watching me, that this was her property. Even through my pain I could feel myself smiling with pride. She shifted, recrossed her legs, and put them back in my ribs. I bit down again on the cotton, grateful that I hadn't dropped it and that it hadn't been removed.

Then I felt her breathing in my ear, whispering for me alone. "You think it's all over, you think I'm finished now? I've got a lot more in store for you. We're only just beginning." She laughed. Next, I heard the shift of a body

66

against leather, and I thought I heard the sound of a glass being put gently back on a table. Her hands spread the cheeks of my ass, and slowly she positioned something between them. Was she taping me open? No, whatever she was using began to prick. One, two, three, I lost count of how many it was, and still had no idea what it was. I realized I could no longer flex my ass. If I did, I stabbed myself. Then that horrible thing (the birch?) that she was just using was picked up again. My cheeks and thighs were again its targets, only this time there was no way to clench. God, what was she using that was causing such pain? It was actually far too inflexible to be a birch, and yet I knew that it had to be wood, many, many pieces of wood. She seemed to like the effect that she was having.

She stroked my ass once or twice, and swatted at it playfully, and then harder. Piece by piece, she began to remove whatever it was she had used to separate my backside. I desperately wanted to see it. I wanted to look up into her eyes, to try to know what was going on, but all I could do was listen, and feel, and cry.

She checked me all over, and poured some more liquid against my back, just a few drops here and there. And then something else. I didn't know what it was at first. I heard her voice—silky, cajoling: "You've always fantasized about this, now I want you to feel it. Feel the reality of your fantasy."

I couldn't tell what it was for three, four, five seconds, and then a burning sensation overcame me. The sensation got worse as it spread, slowly, insidiously, through the cuts and welts that went across my back, shoulders, buttocks, thighs. It was seeping into my wet skin, creeping into the open scrapes.

"Oh, God, it's salt! No. Oh, Jesus!.."

The heat, the internal heat it generated as it ate into my skin, was beyond agony. I knew what plantation slaves felt like. The salt was a distinctive punishment all its own. I didn't know how much she was pouring. I heard her rub her hands together to get off the last bits.

She propped her feet up on my back and watched me writhe, listening to my muffled screams. Her laughter echoed in my ears. Her hand rubbed into the already open cuts whatever salt hadn't adhered to my wet and sweaty body. I wondered how much of my blood had dripped onto the inside of my white corset. It seemed an odd thought.

Hands undid the chains that held my wrists and ankles. I was too miserable to move and far too exhausted to fight. "Well, you're half finished," she said, and I heard her tell unseen listeners to turn me over. I couldn't believe what she was doing. No, I'd had enough. I caught glimpses in the darkness of hands and faces as they repositioned my wrists and secured them again to the floor. My ankles were also reshackled so that I was spread, again.

"Now that you know what it feels like, you know what to expect. You know the kind of pain you're going to receive."

I looked up at all of my worst nightmares. I prayed to God that I was dreaming, and that I would soon wake up. But, no, it began again. My owner leaned forward, and grabbed my left nipple and smiled. She pulled gently, then harder, and harder, until I thought she was going to pull my nipple off. "Did you think it was over, slave? Did you think I was going to be merciful?" She smiled.

The other hand reached down and took the other nipple giving it the same treatment. When they were pulled as far as they could go, she twisted, first one way, then the other, she tormented them for an eternity. She let go, laughing.

After she had a sip of wine, I was allowed to see the tools of my destruction, and this time I could identify them. At first I thought I was looking at some long, old-fashioned broom, then I realized it was "millions" of long pieces of branches that I had cut earlier from her Flowering Plum Tree, all bundled together. She brought them down against my breasts. I screamed as each piece cut into my skin. I was grateful that there was something between the rawness of my back and the concrete floor. She leaned forward in her chair, laughed, looked at me and then stood up. Someone pulled the chair away. I tried to focus on the tower in front of me. She directed the "broom" at my nipples, tipping them, cutting into the tender flesh with the ends of the branches. When she was bored with that target, she took new aim, between my legs. Hard. It felt like the full weight of her body was behind each blow. The pieces of twigs were splintering and breaking off, imbedding themselves in my skin.

"Yes, slave, I can do anything to you. Isn't that correct?"

She continued to batter my private parts, and I could hear the women in the group behind me gasping. Sometimes I could see her face, sometimes I could only focus on the implement that was being brought down against me. She grew tired of the game and dropped the bundle of branches right near my head. I got a good look at what had caused me so much hell. But it wasn't much of a respite.

Next came the strap. It was one of the new toys that she had brought back from South America. The weapon was draped very gently between my legs. She was taking aim. Madam tapped my private parts a few times, and then lifted the strap and brought it down full force, again and again. I screamed until I thought my throat would be raw. I

screamed so loudly I was surprised that anyone around me could stand the sound, but to my owner it was music. The strap soon found other places on my body, against my nipples, the sides of my ribs, my breasts. Nothing was sacred except my face. The strapping must have been hard work.

Countless strokes, and countless tears later, Madam sat down again, and put her feet up, my breasts became her cushions.

Yes, now I knew what it was like in hell, but it was worth it to see her look of satisfaction. No, maybe I was wrong, maybe it was pride I saw on my owners face.

OUR INTRODUCTION

October 27, 1982

It was just a day like any other day on the East Coast. I was staying at the home of one of my slaves. My slave had talked me into agreeing to meet a young woman whom she considered would be a "perfect" addition to my stable of slaves. I wasn't interested as I find meeting potential slaves to be tedious, and usually unfulfilling. However, she was so insistent I decided to humor her and acquiesced. I was going to speak to a Women's S/M group in Manhattan on Tuesday, so I might as well meet this "perfect" potential slave first.

We drove to a little cafe on the West side, she was waiting inside. My slave told me she was beautiful, and that she was eager to meet me. However, her actions didn't confirm her desire to meet me. I was perplexed. Usually people who are looking forward to meeting me treat me with respect and are delighted to listen and want to impress me. She did not. She was like a beautiful butterfly who wouldn't settle down. My slave had also told me we were meeting one woman, and here were two. She explained that she had just run into her friend from years ago, and they had to "catch up" on old times. I didn't believe her. Not only was it impossible for her to stay seated, her eyes wouldn't settle down, either.

She wouldn't take her dark glasses off, and seemed not to be able to stick to one subject. Her conversation was disjointed, her thought patterns fractured and in chaos, and it was apparent to me she didn't want to be here any more than I did. I was ready to leave. Just a simple "It was nice to meet you," and exit. But that was difficult also. Every time I saw an opportunity to depart gracefully, something happened or someone started another conversation.

She had said I could talk about everything in front of her friend since this friend "knew all about her life." I took her at her word and decided to show her some of my pictures. I always carry pictures taken during scenes when I meet new people. There were men and women in bondage, red bottoms, anguished looks, me in costume, and other dominant women. (I enjoy watching to see what photos the person flips back to. It always reveals their personal interests.)

She was astonished. I could see it in her eyes when she briefly took off her dark glasses to have a better look at the pictures. She would look at the scene, and then at me. I could see her trying to imagine *me* doing these things to the people in the photos. It had to have been perplexing for her. I am not the typical dominant. I do not wear leather, high heeled boots, or any of the other classic S/M fashions. I am a professional business woman, a wife and mother, and I like to look stylish—prim, even. I do not like to stand out in a crowd advertising my proclivities, so I was wearing a paisley silk dress. I dressed as though I were going to work. I have a motherly appearance, and don't try to disguise my softness in social situations. She was, indeed, confused.

Her friend eventually left, and then it became impossible for us to leave her. Now she became more obviously interested. I guess the pictures did something, and my

explanations were convincing. She settled down a bit, and it became easier for us to interact.

Her name was Alex. She was in her late 20's, a model, actress, and financially independent. Having been raised in the top social circles, she name-dropped with ease, not to impress. She was dressed in expensive designer silks and cashmere, and lived in a beautiful apartment in Manhattan. Never married, not tied down to anyone or anything, she was enjoying her life, playing most of the time, and generally surrounded by an entourage. She had trained two of her friends to "top" her, playing out her "nightmares." However, she had never been dominated. She was a picture of dominance, herself. She snapped her fingers, and everyone willing obeyed. That was her lifestyle.

It was getting late, and I had dinner reservations at one of my favorite restaurants in little Italy, so it was time to go. Since Alex was now alone, my slave encouraged her to join us. She surprised me with her immediate acceptance to the invitation.

Dinner was more interesting. Conversation became reciprocal. She talked more about herself, and surprisingly, about some dungeon equipment she had helped to construct. She invited me to her friend's dungeon to see what she had made. In fact she asked that I "please" come over when it was convenient. Alex was becoming more interesting to me by the minute. She was not just a paper doll, but had taken the initiative to create something she wanted. However, she also let me know her interest was not in pain of any kind. Her scene was strictly bondage and sexual torment.

I lost sight of Alex when we got to the meeting. Women surrounded me to greet and chat as it had been a few months since I had been in New York. My talk for that evening was about my experiences as a dominant who had

73

been living the lifestyle for twenty years; my household; my slaves; my interests; my activities. While speaking I began my usual eye-contact and saw Alex sitting with a close friend to the right of me. She was hanging on my every word, but hiding herself from my immediate view. I could feel her eyes on me at all times even though they were obscured behind those dark glasses. She appeared mesmerized.

After the lecture part of the meeting, I began a demonstration of my caning and spanking techniques. I asked for volunteers. She was not one of them. I spanked several, and caned a few. She did not take her eyes off of me.

After the meeting, I spoke with many, and noticed Alex was always within earshot of me, listening carefully. She didn't let me out of her sight the entire evening. We exchanged the usual pleasantries before leaving for the evening, and she, once again, invited us to see her dungeon and equipment. I accepted.

It was indeed a doll house dungeon. A little apartment just behind the Plaza Hotel, unoccupied except for bondage equipment, with special lighting, and a pleasant sitting room. Her friend, one of her "tops," had designed the lighting and many special effects in the dungeon, and was showing me all the little gadgets. I was courteous, but not genuinely interested in any of those items. I was eager to see the piece Alex had made. Eventually Alex proudly brought out the chair, and I was indeed impressed. She had taken a simple piece of equipment sold to her for bondage, however inadequate, and made it into a unique piece that was something completely different. A piece that I wanted, and would later copy for my own dungeon.

What was it about this beautiful, mysterious, paradoxical

74

woman? I wanted to dominate her, I wanted to see what made her tick. I didn't really believe she was into the scene on the same level I was, but I felt her interest was genuine. I thought she was more curious than needy. What would she do if I were to take her in hand. How would she react, I wondered, if I were to do a real scene with her? Would she crumble and yield immediately? Would she fight? Would she yell "uncle?" Or, would she silently beg for more? She had gotten to me in a way no one else had ever been able to do. I wanted to remove her from her convenient hiding place behind those glasses. And I needed to see for myself: was she for real, not just a glass doll?

We were at the door, saying "goodbye." Alex was lounging in her overstuffed chair, smoking, making no motion to walk us out, almost ignoring us. I looked at her, and with a sudden impulse walked over to her. Looking down on her, I noticed the unusual buckle she was wearing on her belt. It was a silver hand that appeared to be wrapped around the belt. I reached down and, while saying "If I knew you better I would do this," I clutched the belt and buckle and raised her to a standing position, kissed her hard on her full lips, dropped her back down into her chair, and walked away. She lay there, shocked and incredulous, almost dropping the cigarette dangling from her fingers, frozen for a moment before scrambling to her feet to walk us to the elevator. When she caught her breath, she invited me to lunch later that week. I accepted.

At lunch she was with another friend. This one was also in the scene, another top of her creation. However this top—I later found out she was also Alex's lover—was not to know about the one at the dungeon. (She did live on the edge!) I learned more about this beautiful creature who never removed her dark glasses. She was bisexual and had

many men friends, but they were kept out of this segment of her life. S/M pleasure was reserved for women only, and not for just any woman, only those whom Alex could control. Watching closely, I was discovering more about her all the time.

After lunch, we walked back to her apartment while her top went back to work, leaving Alex alone with us. My slave kept the conversation moving. They had a lot to talk about. I wanted to listen—that way I could study my prey. (I was already beginning to think of her that way.) We spent a couple of hours talking—nothing really about the scene, but life itself. It was a revealing conversation.

While saying our "goodbyes," I seized Alex, pulling both hands behind her back, I crossed them and held them tightly in place as I kissed her once again on her luscious lips. Immediately her mouth opened and invited my tongue. I explored her momentarily, then pulled back, releasing her, and walked away to take one last look at the view of the city from her windows high above Central Park. She dropped to the floor, her legs too weak to hold her, and I heard her ask my slave, "does she do this to everyone?" I smiled.

Before leaving New York, Alex elicited a promise from me to return in ten days for a party she and the S/M group of women were planning. She was very insistent that I return, and her offer to pay my air fare impressed me. Of course, she "didn't want to play with me." She only wanted to watch.

And watch she did on the night of the party. Her eyes rarely moved off me during the evening. However, I had a little surprise for her. I had some bondage equipment made especially for a little scene with her. I had been talking with her top, and for this party we had a surprise for Alex. At

the end of the evening she was presented to me. The scene was brief, the scene was dynamic, the scene was powerful. I suspended her from her ankles and tormented her with words. I never touched her. However her lover/top was not happy. I had not informed her of exactly what I was going to do with Alex, and all the scenes that had been done with her prior to this time were with Alex's direction. The top was not very happy about what I was doing without permission. But I continued.

However, Alex *was* happy. Well, maybe happy isn't the right word, but she was experiencing feelings she had only read about previously. She was experiencing the satisfaction of needs that I realized were innate to her, feeding appetites that were so strong she would dream about them, answering yearnings that obsessed her to the point that she was motivated to create her tops. My scene had not been programmed, had not come out of Alex's imagination, had no permission granted. She had no knowledge of what I would do. I was an unknown factor. I was comfortable treading on sacred ground. In fact, I was getting off on the fear I saw in her face when I told her how vulnerable she was at that very moment, and when I informed her that this was *my* game, and would continue until I finished with her.

I continued the dialogue: I was in control, and what happened next would come from my vast, warped, perverted, and depraved imagination. She had willingly invited this sadistic monster into her chamber of horrors, and had now lost all of her power and control. I would do what pleased me no matter what she liked, and not only was she completely open and vulnerable to me, I was strong enough and powerful enough to impose my will on her. After all, if she could look around the room, she'd see there were twenty-five women watching. And at last count

twenty-four of them wanted to see her humbled, subdued, sacrificed, and punished. It may not be now, but it would happen, someday! And then I let her down and walked away.

I had won her. She lay there throbbing and cumming. The competition had begun.

THE INITIATION — The Convent

February 1983

The dungeon was ready. My slave had done an excellent job getting the necessary equipment in order. Everything had been done according to plan. The robes were perfect, the food was prepared, all the necessary tubes and accoutrements were in readiness. I was anxious. Would I be able to do her scene? Could I fulfill her needs, and still be true to myself? Would the plans I had made for her today produce the paranoia necessary for her scene? Although this would be my first scene with Alex without her lover present, protecting her, her other top would be there. It was interesting that her top wanted me to be much more cruel to Alex than I had decided to be. It was a bit strange. I had organized this scene, but the top kept suggesting that I do things I knew were not of interest to Alex, and in fact would turn her off. As informative as the top was, I knew somehow she was leading me a bit astray. I had to be careful not to fall into a trap.

Alex was brought into a small room outside the dungeon. Her top had given her some information about the scene I had planned. She even knew a bit of the scenario. We had spoken about the plot for the day. The information would give Alex something to fantasize about before the event itself. It would help build her paranoia. She knew, or

assumed she knew, how she would act in given situations. However, she didn't have *all* the necessary information—she didn't know me. She didn't know how I would behave under those circumstances.

The unknown. She could know everything about what was planned for this scene, but she couldn't know how I would use these elements, how I would respond. She didn't have the major, necessary component. With each thought of what might happen she could find a solution, and then another idea would come to her that would need another decision, another possibility, another conclusion, and then eventually lead to another idea that would lead to another decision, another possibility, another conclusion, etc. It was a never ending circle that would continue to wrap her in her own threads of anxiety. This was all part of the scene: in the days, hours, minutes before the event began, she would live the scene over and over.

I cracked open the door just a bit to see what Alex's top was doing to prepare her for the next few hours. Alex was bound, lying on a bed. The top was feeding her information and misinformation about what was going on outside the room and inside the dungeon. She was telling her about all the preparations.

"Nan is so anxious to get her hands on you, Alex, I'm really worried. You know she is a pretty heavy top. She really hurts people, and that's not your scene. You know, once this event begins there's no turning back. I can't protect you any longer. I can only stand back and watch the scene unfold. I'm a helpless bystander, and you may have made the mistake of your lifetime. Well, I guess it's too late to turn back now, isn't it? See where your clit will get you?"

I smiled and left them to continue, donned my costume

and sent my robed slave to tell them we were ready and waiting. There were five of us: one victim, three assistants, and one predator, all women. We were monks in a monastery, and Alex had been caught trying to get in to discover what was going on inside. She had been seen peeking over the wall on several occasions, and now she had been found on the grounds of the property. We all knew she was up to no good, so we were going to teach her a lesson.

I was standing in the middle of the room, my arms crossed with my hands hidden inside my sleeves. My hood was down so my face was obscured. My two assistants were standing in a similar stance at the two sides of the door, waiting to help the third assistant who would bring Alex to me. The door opened to my candle-lit dungeon, and I beheld my robed attendant holding a beautiful woman dressed in a red corselet, red stockings and red high heeled shoes, wearing dark glasses. My assistants immediately went to their places on either side of her. She frantically glanced around the room, jumping when she saw the two robed novitiates at her sides. It took her a few moments to adjust to the darkness before she could see everything. Yet her focus was constantly on the figure in the center of the room: me. I spoke, "Bring her to me."

As soon as they stopped before me, I looked directly at her and ordered her to "kneel!" Involuntarily, she did so. Then, immediately, she began to rise, wondering why she had fallen to her knees. She apparently thought again, and stayed where she had fallen. To obey was not innate to her. She was the one who was accustomed to being obeyed. That was her way of life. She didn't know it, but I was about to change her way of life.

I reached down and removed her dark glasses. She shook

her head. I could read the apprehension in her eyes. She was confused. Why did she kneel? What power did I have over her? Now she couldn't even hide behind her glasses.

I started my interrogation. She didn't really know what was going on, our story line. She didn't really know why she was there and in this position, and the only way she could figure it all out was to listen very carefully to my questions and piece it together. I walked around her while alternating between lecturing and questioning her.

"How dare you invade our privacy? Just who do you think you are trying to spy on us. Tell me, where do you live? Who were you with? What did you see? And just look at you: looking for a little fun, not caring who you bother. Just out for a good time? Tell me, who is with you? No one? Good. Brother James, go check the grounds, and take the dogs with you. Believe me, you nosy little bitch, if he finds anyone out there, they will bleed to death before the dogs let go. Where is your car? Tell me, where did you park? Go on, check to see if her story is correct."

I continued my questioning and accusations, and she informed us that she was alone, that no one knew she was here. My assistant followed my orders and left the room.

Her answers were as disjointed as my questions, and I didn't give her much time to answer. It seemed her tongue would not work for her, and words were almost impossible. Her eyes were following me everywhere I paced, and they were darting between my assistants and me, afraid that at any moment someone would grab her. She didn't know what would happen next, and really, neither did I. I fed off her fear. If she reacted to something in particular, some word, some action, I would follow that thought for a time, before abruptly changing the subject. She was confused.

"You'd better pray as you've never prayed before that

your story checks out. If it doesn't, we may have two or three sacrifices for the weekend's observances. Now, that would be interesting, wouldn't it Brother Mark."

The questioning continued for a few minutes before Brother James returned. When he did, he announced that he had found no one, and had moved her car into the interior of the grounds where it couldn't be found.

With this announcement, the realization that her reality was very closely married to her fantasy became terrifying. The only people in her life who knew where she was this night, were right here with her. Was she safe? Had she really been so stupid as to allow herself into this fantasy without a safety net?

"Ah, that's good. Now we can relax. I hope, Missy, that we won't disappoint you tonight. We do welcome surprise visitors, especially ones as beautiful as you. I think you will be quite amazed at what we have in store for you. You want information? Well, instead of watching us, you will be the focus of our studies tonight, and we will watch you." I laughed and walked away.

"Brother Matthew, release that hoist. Brother James, get the cuffs and put them on her wrists. Brother Mark, just hold her there in readiness for us."

Then I turned to her. "Young lady, just look at you! All dressed in red. Doesn't that tell a tale? You should know better. Red corset, red stockings, red high-heeled shoes: Are you trying to tell us something? Who were you trying to seduce tonight? Certainly not us. Well, we aren't interested in a little slut. But we do have methods of cleansing and purifying you, and then, maybe, you *can* be of use to us. We will decide if and when you are ready."

After attaching her wrists to the hoist, I stretched her by raising the hoist so only her toes touched the floor. I started

playing head games with her, studying her reactions to my words. I would continue with the thoughts that affected her, all the while prodding her with my whip. A few snappy slaps with the crop on her corset just to keep her on guard, walking around her, forcing her to turn around in a circle so she could see my face. I would turn her away from me, then spin her back to face me, repeating an unanswered question. (Of course, she is almost incapable of speaking in this state of mind.)

When I tired of this, I pointed to one of my assistants and demanded that she disrobe. She was to be punished for allowing this intruder over the walls. Someone had to be responsible for our safety, and I decided she would be the one. I had her bound and hung by her wrists. I began whipping her with my cat of nine tails, all the while looking at our visitor, telling her that this may happen to her next, warning her that her fate was completely in my hands.

Alex's eyes darted around the room, looking at everyone watching this spectacle. All the focus was on the one being whipped, her moans, her cries, her pleading. The disobedient monk was enthralled by the whipping, but my lovely victim watching it was terrified. What had she gotten herself into? I continued to whip the naked monk who was hanging there passively savoring the light whipping. My strokes began to get more severe and relentless until the monk started crying out. Her moans became whimpers, then sobs, and finally screams. Dropping my whip, I went behind the monk, circled my arms around her and turned her to face Alex who was almost crying in empathy with my monk. I held the monk's breast in my hands, and watched Alex while she watched my hands caressing the whipped monk. I could see she was transferring herself into my arms. It was actually happening to her in some amazing

84

way. Somehow any action she could observe she would allow herself to feel whether she wanted it or not. That was good. I knew she was not able to take pain at this time, but she would by osmosis.

After fondling the monk, I once again began to whip her. This time I didn't whip as hard. The whipping was firm, but she was able to take it. I whipped every part of her body: Her back, her breasts, her stomach, her legs, her bottom, and finally between her legs. Each time she caught her breath, Alex gasped as well. Again, it was happening to her.

I had the monk released, and she fell at my feet, curled her body around my ankles and held on for dear life. As I looked at Alex, still suspended on her toes, I visualized her in the place of the monk. Would it ever happen? Would she bow to my will? Would she learn to endure pain?

I released Alex, and she walked to the bench carefully, refusing any help. She was proud and arrogant, and was going to show me that I hadn't gotten to her yet. I had the monks firmly strap her to the bench. Everyone else was pulling and holding her, but she only had eyes for me. What was I going to do next? I was her threat. They held her legs apart. Her sex was wet, actually dripping. If I had doubts before, they were gone now. She had felt my power, and I hadn't even touched her yet.

"Just look at you. You're all wet! My, my, such an indecent little girl."

I touched her and she shuddered.

"Is this what you want? Or were you just looking for a little information. *Who sent you?* Tell me. *Who?* Was this your idea, alone? What did you think you would discover here? Think we were doing something indecent? Or just curious? Well, well, such a naughty little girl. Look how

big you have become (touching her sex), and you're getting bigger—so wet."

I paused.

"Just what did you think was going to happen here? What? You're stimulated from the thrill of this adventure, aren't you? The thrill of the unknown. Nothing's sacred to you, is it? Just what's going to happen next? Oh yes, you'll see soon enough, but you're not ready for us yet. You must be absolved. We'll prepare you. Ah, yes, if you survive the ceremony today, maybe, just maybe you'll get what you want, or think you want, or are afraid you'll get. But maybe you'll get more than you bargained for. However, first you must be cleansed, you will be purged. All those wicked thoughts must be purified. It is not only your body, but your mind, too, which must be cleansed."

I continued to explore her body, pinching, probing, stroking, caressing, examining her, scrutinizing her, while talking to her. Looking into her eyes, observing her, studying to see her reactions to my words and my hands, delving into her brain—into her sex. The two had become one. She had lost all control, and that loss made her even more defenseless, vulnerable and paranoid. That vulnerability was an essential weapon in this recreation.

Leaving her tightly bound to the bench, I busied myself with the other monks. Using one as my footstool and one to massage my neck, I enjoyed my pleasures, playing with the monks in any position where Alex could observe my actions. She felt everything I did to the others. I didn't look at her, I just listened. She reacted to even the simplest touch as though it were her body I was touching, manipulating, whipping, and restraining. She watched as I dripped wax on the large breasts of the sacrifice at my feet. She cringed with each drop of the burning liquid. Her eyes followed

every movement of the knife as I peeled the wax off the flushed skin. She consumed me with her eyes. I found myself performing for her. Even from this distance, even while attending to another, I was feeding on her energy and attention.

I took my time with the monks, then decided to change the mood. I called the monks to me and told them to set up for dinner. We discussed how we would use our victim as a centerpiece for the table, and what would be the best way to feed her. We talked about how and where we would hang the bottles, how we would attach the equipment to her, and what foods should be prepared for her. Of course, we had discussed all this in advance, and everything was ready. But I wanted to kindle her imagination. I wanted her to watch the development of this bizarre situation and have it increase her anxiety. It worked, she was startled by our conversation and would interject a "what?" here and there. She tried desperately to figure out just what we were talking about. She was indeed confused. Of course we ignored her, which flustered her even further.

We all set about doing our chores. Hanging the bottles and tubes, lowering the table, which was hung by chains, and placing the attachments for our table adornment. Her eyes never left the action which was taking place in the center of the room. With each tube or bottle or chain she audibly gasped. It was an interesting phenomenon. Her imagination was being expanded by each addition to her reality, they were becoming one. And with each new addition, another action took place. It was becoming too confusing for her. She didn't know what was real and what was imaginary at this point. Rapidly, her imagination was becoming her devastating reality.

"Attention, everyone! It's time to adorn our table.

Release the trollop so she can get the circulation going again, allow her a moment in the bathroom, then *let our party begin!*"

She had more difficulty walking this time, but rejected any help. She was shown where the bathroom was, and granted an amount of privacy. Once finished she was immediately brought back to me and lifted onto the dining table. She had gained a bit of composure, but seemed surprised that everything she had decided was only imagination was indeed real. The hanging tubes made her cringe. She hardly resisted as she was attached to the table. She knew struggling would only make her weak, and that it would be pointless with so many hands available to hold her. She must have thought she might even anger me further, and knew that that *must* be avoided! Shortly, the food was brought out and placed around her secured body. While my assistants were adjusting the bottles and tubes to convenient locations, I began talking to Alex.

"Well, well, young lady, it's a shame you can't be a guest at our table, but you weren't invited, and so far haven't earned the right to be treated as a guest. So we'll use you for our amusement. You'll adorn our table, and we'll study you for our entertainment. It seems only fair, doesn't it? You were trying to have fun watching us and you were caught. Pity, Miss, but you've lost your little game. We captured you, and now it's our turn."

I laughed.

We all sat at our assigned places and began to eat. Our conversation centered around the running of the monastery, the problems with intruders, managing the donations, and our unfinished renovations. All the while our table decoration's eyes darted from face to face, trying to decipher reality from the fantasy we were portraying. It was

becoming more and more difficult. The fantasy had become her reality.

I watched her confusion, her bewilderment. It was all becoming chaotic as she began to lose her ability to follow the conversations. It was all so perverted. Alex was aware that she knew all of us, but her mind could only hold onto that frame of reality for a short time, and only while tensely concentrating. The minute she relaxed that concentration, her mind would propel her back into the illusion we were portraying. The longer it went on, the less she was capable of bringing her "true" reality back. It was fascinating.

We took our time, enjoying our food, playing with our victim's mind, creating conversation regarding what we could or would or maybe should do to the creature before us. Our imaginations ran rampant, inventing situations which were inconceivable. We were living our parts, unrestrained.

"We can keep her here for days. No one knows where she is, and certainly no one would expect her to be here. It would be at least forty-eight hours before they started looking for her, that is, if anyone misses her. I'm sure she has pulled stunts like this before. They probably think she will return when she has become bored with her adventure.

"Oh, Yes! We could watch her and study the effects of the various tortures we have been reading about. I've always wondered what would happen if a person were kept in rigid bondage for several days. What would happen to the muscles? They would probably begin to knot up, and become terribly painful. What about dripping water? I've only read about the Chinese tortures—they were so fiendish. I'd love to try some of them."

We relished the panic we saw building in our victim, and continued until I began to tire of the exercise. "Brothers!

Here we are eating this delicious food, and I'm sure our *guest* is hungry. I think it's time to feed her." She vehemently shook her head "No!" There was no doubt in our minds that she did not want to be fed. However, I ignored her and continued.

"Of course, it can't be the food we are enjoying, but you did prepare some special nourishment for her, didn't you, Brother James?" We began busying ourselves, getting the tubes and apparatus in place to attach to Alex. She clenched her teeth together when she saw me lowering a tube toward her mouth. I smiled.

"I suggest you obey me at this moment. I can hurt you so easily. It would be so simple, just, like, this." While speaking, I began squeezing her cheeks together. When it began to hurt, she unclenched her jaws, allowing me to insert the tube into her mouth. While holding it in place, I instructed the monk to release the food. Baby food was perfect to feed her, all she had to do was swallow. I warned Alex that she should swallow and not spill a drop. "Hold still and swallow, I don't want you to choke. You'd soil your beautiful garments. Now, that's better. Just go with it. Don't fight. Good girl. You see, when you cooperate, things are much easier. Good. Okay. That's enough for now."

It took quite some time for all the food to drain out of the bottle into our visitor. When I finally took the tape off her and removed the tube, her mouth was still full. I could see the battle she was waging, trying to decide whether to swallow or spit. Standing over her I said, "Go ahead. Go on, spit it out at me. You want to, don't you? Just be warned, you are in a very vulnerable position, and it would be my pleasure to hurt you. Now, if you want a scene you will never forget, go ahead."

She quickly swallowed.

"All right, Brother Mark, get the coffee and desert, and don't forget the whipped cream. Brother James, clear the table so we will have more room to enjoy our plaything."

Desert was simple, just cookies and coffee, and a can of whipping cream. We relaxed and drank our coffee, laughing, joking, bantering with each other. We were in no hurry. After all, we had all night and wanted to continue the suspense of the evening for our visitor. Nothing was said to her, or even about her for a time. She was just a table decoration, and would be available when we were ready for her.

Eventually our chatter slacked off, and one by one we began spraying the whipping cream on Alex, making designs, wiping it off, licking it off, even biting it off. Laughing and enjoying our sport while Alex struggled in her bonds. She didn't know where or when the next finger, tongue or tooth would touch her. We were like children with a new game, never looking her in the eye or talking directly to her. She was an object, and we treated her as such, dehumanizing her.

"All right, Brethren, that's enough for now. I think it's time for the ceremony to begin. Release the girl, prepare her, and bring her back to me naked, and ready for the ritual."

They released her. I watched it happen. I watched her as she unflinchingly stared at me. Her body was being manipulated by everyone, and she passively allowed herself to be maneuvered into various positions as though she were not in the body being moved and handled. Her eyes followed me everywhere I went. I kept myself moving, and she watched my every movement. What was going to happen next? The questions were flooding her eyes. What

would I do with her? Which of all the damaging equipment that filled the room would be used on her? Where would I take her next? After all, she had never before been to this place of submission, not in all the games she had played previously, and now she was putty in my hands.

I wonder now, was this the point when I first knew I had to possess her? Was this the moment I became sure that I must make her mine? Or had I decided that with the first kiss at her apartment?

While she was being cleaned up in the bathroom, we rearranged the room. I had the monks remove the table, and pull the horse into the center of the room. I prepared myself. I put on the harness and had a monk bring me the item I had acquired especially for this evening's activities.

Alex needed and accepted assistance walking back into the room. Each time she reentered the room—and my presence—her resolve was lessened. They brought her to me and I ordered them to place her straddling the horse, bent over and strapped into position. Her wrists and ankles were also attached to the horse.

"My, my, what a charming offering for me, this beautiful body. You take care to keep it so lovely, don't you? You never dreamed it would be for my pleasure, now did you?" I stroked the trembling body, caressing, fondling, probing into her exposed sex. "You're so open for me. So wet. So ready. Good. Now it's time. You will be purged."

I opened my robes, and allowed my new appendage it's freedom. I slowly penetrated her moist sex. She shuddered. Her entire body was being ravished, devoured, consumed as I thrust into her. Each time her breath came out in gasps. At that moment nothing else was important. Nothing else existed. There was no game, no competition, no fantasy— only reality, only her fulfillment. Only *me*! I withdrew from

her, my body trembling, my breathing labored, my excitement at its apex, and slowly walked around in front of her. She lifted her head to gaze into my eyes and I spoke. "Open your mouth!" She immediately did as instructed, and I used her. I was pleased. It was over—finished. I had my assistants release her. Trembling, she fell into my arms and held on for dear life. There was no fight left, no strength, no energy. I had consumed her. I had drained every ounce of her substance. She was inside me, electrifying me, energizing me, inspiring me. And I remained inside her. She felt my power, my control, my dominance. I possessed her, and she fell in love.

LATE AGAIN

April 1984

Carol is always late. The effect of her tardiness, the ominous "spanking," has been hanging in the air like a damp cloud.

The movie was funny, the dinner was delicious. I laughed and chatted like nothing was wrong, not even mentioning "later," but Carol knew. She could hardly eat. I could see that she couldn't even concentrate on the movie, but she knew she had better act as though nothing were wrong. Carol was afraid to annoy me any further. In the car on our way to my house, Carol couldn't speak, but I chatted on as if nothing were wrong. As soon as we were inside the house, my expression changed.

"Carol, put our coats away and get me a glass of wine." The change in my tone of voice visibly alerted her. "When you've done that, put on some soft music and stand here in front of me, we have something to talk about."

I sat on the couch, waiting for Carol to bring me the wine. She returned and handed me the glass, then stood in front of me as I had instructed. I sat there for several moments sipping the wine, relaxing, letting the tension build. This must have seemed like hours to her. Finally, feeling like she would wet her pants, Carol asked for permission to go to the bathroom. I looked at her sternly for

several moments, finally saying, "What are you talking about? You were in the bathroom more than you were in your seat during the movie. What were you doing in there, playing with yourself? It hasn't been more than twenty minutes since the last time, so you'll just have to wait until later!"

"God, Nan, I really have to go! Come-on!"

"How dare you speak to me in that tone of voice, you arrogant little brat."

With that sentence, I slapped her face. She reacted with shock and surprise, putting her hand to her injured cheek, and I continued, "Now you will just have to wait longer. And if you wet yourself, it's going to be much, much worse."

Perhaps it was only ten minutes, but it felt like hours to Carol. I was amused watching her shift her stocking-clad legs back and forth. After finishing my wine, I eventually spoke. "You know what's going to happen here, don't you?"

"Yeah."

"And why?"

"Mnghslle"

"Quit mumbling, Carol. Speak so I can understand you! And stand straight. Your posture is terrible! You look like a little trollop with no class."

"Yes, Ma'am."

"Now, what *is* that reason, Carol?"

"Because I was late, Ma'am."

"Late *again* is the reason. If this were the first time, your punishment would be over now. I would have turned you over my knee and spanked you on the spot. But I've done that before, many times, and it obviously hasn't taught you anything. So tonight I intend to educate you on

96

the subject of punctuality. Now, lift your skirt to your waist, and hold it there. Good."

I stood up, and—taking her by the ear—marched her into the corner. "Now stay there while I get ready to teach you some manners. Pull that skirt up. . . higher. Hold it up and out of the way. (Slap!) I want to see that nice big bottom of yours, the one I will be working on for the next couple hours. (Slap!) Enjoy the nice cool feeling you have now as it will be feeling quite different soon. Don't let your skirt fall as I will have to punish you for disobedience as well if you do. (Slap!) You wouldn't want to compound your problems tonight, now, would you? (Slap! Slap!)

Leaving Carol in the corner I went into my bedroom and took the necessary instruments out of the drawer—my toys. I selected my "lady spanker," a few pieces of red rope, and a razor strop. Then I took my hair brush off the dresser and went back to the den where I knew Carol would still be standing, waiting obediently in the corner, with dress held high, barely able to breathe lest she should earn further punishment. Carefully removing the chess pieces from my game table, I pulled the game table/punishment bench into the middle of the room. Carol had known me long enough to be able to envision what was happening, and I'm sure it heightened her apprehension. Also, her genuine and urgent problem of needing to relieve her bladder was becoming severe. She *had* to go! And, her dinner felt like a ball of lead in her stomach. God, she knew she was really going to get it tonight! Not that she didn't deserve it. She really could have been on time if she tried. Why, oh why didn't she do that?

Suddenly, I was behind her, touching her vulnerable bottom. "So soft, and cool. My, I don't think you've had a real spanking in a long, long time, have you, Carol?"

"Please, Nan, I really have to go to the bathroom. Really!"

She was crossing and uncrossing her legs trying to lessen the urgency of her bladder.

"But you didn't answer my question, Carol. Just how long has it been since you've been across my bench?"

"I dunno," she said, sniffing, "oh, please."

"What? Quit mumbling and speak distinctly! (Slap) I (Slap) can't (Slap) stand (Slap) your (Slap) whimpering (Slap, slap, slap)!" I punctuated each word with a well-placed spank.

"Ow! Ow! Oh please, Nan, let me go to the bathroom, please. I'll do anything, please."

"Is it worth the cane, Carol?"

"The cane? Oh, no, please, not the cane."

"All right, then, answer my question. How long has it been since your last strapping?"

"I'm not sure, Ma'am, two months, maybe."

"Much too long it seems. You have forgotten your place, as well as your manners, and you even forgot what to call me. Well, tonight we'll have to start your training again, and get things back in proper perspective." As I spoke, I began pulling Carol's panties down and prodded her crossed legs apart.

"Your bottom is so white. Perhaps I should take a *before* picture, since I doubt you'll ever look the same again. Put your hands behind your back, but don't let your dress fall. Good." I noticed her panties were damp, so I told her she had one minute to relieve herself in the bathroom.

"If you're not back within that minute, I'll come in and get you, and believe me, then nothing will stop me from using the cane on you."

She was very prompt, and when she returned to me I

took one of my ropes and tied it around her wrists, rather tightly, as Carol is good at getting out of her ropes if not well secured. Taking her by the ear, I led her to the game table and helped her get across the bench in the right place, adjusting her body until her bottom was positioned perfectly. (Carol knows this table—all too well.) Not much was said by either of us while I tied each ankle to the legs of the table. In this position she is bent over, face down, her bottom is elevated over the two foot square table, and her legs are stretched out straight. I fastened her legs to the seat of the bench with straps, and her hands behind her back. I pulled her panties down to mid-thigh. I took care to make her feel her vulnerability by inspecting her bare bottom and tenderly caressing each mound, probing between her cheeks.

"*Attention!* Carol, the time has come. I know you're eager to get on with it, so, here we go." Smack! Carol groans as I apply a few preliminary swats with the lady spanker. (The lady spanker is a copy of a thick leather paddle, which I found in a Girl's School in Scotland. Because it has holes, it can raise blisters if I'm not careful, and I was in no mood to be careful.)

"I'm sorry, Madam. I'm really sorry. I know I've been thoughtless, and I promise I won't ever be late again. Ow! Oh, please, I'm sorry, really."

"You're always sorry, but too late. You never think in advance how much time it will take you to do anything. You just let me wait. It surely doesn't show respect. Just how do you think I feel while I'm waiting here. I could have been doing the things that were important, not just waiting. I don't think I've ever really gotten to you, to your *brain* with the spankings you've had before. But I will tonight. I *will* teach you a lesson tonight, one that you will

never forget!"

It had started. I wasn't playing now. Each swat with the spanker was with a full arm swing. I took my time. It took around five minutes to deliver about 75 swats. All my strength went into each swing. (Well, almost all my strength, I needed to save some for later.) Slowly, I worked across the fattest part of each cheek, making sure some of the strokes fell across the bottom of the bottom as well. The tears were real, as well as the promises, at least for the moment. But both Carol and I knew this was just the beginning, if she were really going to change. No need to hurry. I let her catch her breath. I sat and admired my handiwork, and reflected on the present scenario.

Carol had finally stopped crying, and tried to convince me to give her another chance. She knew it was futile, but maybe just this once I would relent, so it was worth the try. However, we both knew she craved this punishment, and I needed to give it to her. Before the punishment begins each time, she would do anything to postpone it, even indefinitely, or to reduce the severity. Then, after it's over, she will be extremely happy that I didn't give into her pleas for delay or leniency. However, right now she would do anything, anything at all to end it.

"Carol, you and I both know you need this. It's obvious, by your actions, so I'm not going to stop until I'm convinced that you are really sincere in your determination to change your ways, but that won't be for another hour or more. So just save your breath."

I delayed to intensify her anticipation.

"Now get ready for the hairbrush. You do remember this brush, don't you? The one you love to use on my hair. Oh, yes. It's such a beautiful brush. It's hard to find brushes like this here in the U.S. A good friend brought it back

from England for me, particularly for me to use on people like you. It's a pity, we Americans have forgotten the value of a good old fashioned wooden hairbrush. Everything I see around is plastic, and not only doesn't it give the same punishment, but it doesn't even sound good. Now isn't that nice? Just feel how smooth it is on this side."

Smack, smack, crack!

"Ow. Oh. Oh, no. Please, Ma'am. Oh, God! Oh, God, it hurts. Please, not the brush. Please. Ow. Oh, it hurts! Oh."

I set up a rhythm, but not a pattern. All the strokes landed on the fat bottom cheeks. I made sure a good number of the swats were on the part of her bottom Carol will be sitting on, and, of course, not a few across the crack. Maybe a stray one here and there on the upper thighs, but not full strength there. (I don't want to cause contusions on the thighs as the brush is heavy and the veins are close to the skin.) After a few minutes of this Carol can't keep still. She is struggling against her bonds, trying to cover her bottom with her hands, doing anything to escape that dreaded brush, even momentarily.

"Keep your hands out of the way. You know better!"

After she made a few attempts to slip her hands down far enough to cover her bottom, I grabbed the rope with my left hand, pulled Carol's hands up high on her back, and delivered a volley of quick, severe swats with the brush. These were to punish her impulsive attempts to cover herself. After about twenty or thirty solid, well-placed smacks spaced ten to fifteen seconds apart, I rendered a barrage of the fast, hard, full-arm strokes that always cause Carol to scream.

"How dare you? You incorrigible little brat! You know better than to scream. I can't believe how little control you

have of yourself. Remember, if you cause a neighbor to come over here to investigate your screams, I will show them just what *is* happening. And then I'll be forced to show them the letter you wrote me about how you desperately need discipline. Remember, you wrote that you can't live without it, and that I am saving your life by punishing you in whatever way I feel is necessary. Is that what you want?"

"Oh, no, Ma'am. I'm sorry." She was sobbing as she spoke, "I . . . I just can't help it. It hurts so much, and my bottom is so sore. I don't know how much more I can take. Oh, I'll be good, please let me show you. Please, I've had enough, really. I've learned my lesson, Oh, please untie me, and I'll never be late again. Please? Oh, thank you, Madam, thank you."

I untied Carol's hands. Then, suddenly—while Carol was busy rubbing the welts on her bottom, thinking I would untie her legs next—I grabbed one of her hands, pulled it out in front of her, and tied it to the front legs of the bench.

"But . . . what are you doing? I thought"

"Oh, be quiet! I'm getting sick of your whining and complaining. I'm also getting tired of you trying to cover your bottom. I'll let you up when I'm good and ready. I will decide when your punishment is over, and it isn't over yet. You have not learned anything yet, but you will. Believe me, Carol, you will learn, and you will learn tonight!"

Carol sobbed as she recognized *that* tone of voice: every word chopped and said through clenched teeth. Of course, she realized that I was right, but she felt sick and utterly helpless. She had been found out, and knew now she must pay the price.

With both hands and feet tied to the bench, she was there

to stay. The only movement she could make was to wag her bottom around. So I decided to make her feel attached to the bench, and put a strap around her waist and under the table. She moaned when I cinched it tight. Now she couldn't even twist. She could barely wiggle. There was no escape from whatever I wanted to do.

I left the room and returned with a knife and a jar. Carol, being very alert, gasped at the sight of them, and asked what I was going to do. I ignored her question and walked to her feet—where she couldn't see what I was doing—and simply cut her panties to remove the final veil from her posterior. "Carol, I'm going to put some cream on your bottom. I don't want you to start bleeding. The pimples are starting to open and I don't want you to get blood on my strap like you did last time."

I smiled. I knew the spanking would hurt more after applying the cream. Somehow having a damp bottom makes the strap or paddle sting much more. I also knew something she didn't know: if this punishment had to be repeated I would use Tiger Balm. "Well, now that you've had a nice rest, I know you're eager to get started again."

"Oh, no, Ma'am, that's all right. . . ."

"Well, I think you've had enough of a rest, and your bottom has cooled down sufficiently, so it's time to get back to the lessons. Are you ready, Carol? Answer me!" Smack, crack!

After a few more strokes, she choked out an answer, one word at a time, "What . . . ever . . . you . . . say, . . . Madam. Oh, that hurts. What is that?" Carol tried to twist around to see what it was that I was using on her tender rear end.

"Oh just a little something I made the other day. It's just a piece of wood. A slat from a hard wood floor. I call it my

ruler, but I carved a handle so it fits into my hand very comfortably. Like it? (Smack!) You'll remember in the future, when I ask for my ruler, to bring me this little number, won't you?"

"Ow. Oh, yes, Ma'am. Oh, it hurts! Please, Ma'am. Oh, ow. I don't know what it looks like. Oh, please, it hurts! Please, Ma'am. Oh." After fifteen or so swats, I decided to let her see the "ruler," and demanded that she kiss it. Putting the "ruler" away, I picked up another favorite little toy.

"Ah, my razor strop! I love the strop! Now, we can get down to the real business of this evening. It's a shame I don't have a woodshed. That's where a good, old-fashioned strapping should be delivered. So tonight we'll have to improvise. If you hadn't been so late, I wouldn't have to go to all the trouble of strapping you, and by now we would be relaxing, enjoying ourselves, talking. Instead, here I am wearing myself out on your behind. See what trouble you give me?"

While giving that little speech, I punctuated each word with that horrid black strap. Carol had a hard time listening to me as the tears were expelled from her eyes by the agonizing pain she was feeling from the intense, solid, heavy strap. Each stroke brought excruciating, searing, white-hot pain—burning, blistering her tender, throbbing, raw bottom. Nothing, nothing could compare with the cruel pain that strap was capable of delivering, nothing except the cane.

Now that I had worked myself up over having to do this exercise instead of relaxing, it would be even worse. How dare this little scoundrel complicate my life!

"Oh, Nan, please. . . ." Carol was sobbing again.

I had taken only forty or so strokes with this strap, but

every one was a full arm swing, and I almost came off the floor each time I brought that strap down. Carol was begging me to stop, imploring me to believe she was sorry, and to forgive her, or, at least, to end the punishment. The fight was gone. There was no more straining at the bonds. She lay limply there on my bench, tears coursing down her cheeks, breath shuddering, hiccuping, sobbing, and promising complete obedience. At this point it was useless to continue. Carol had surrendered completely to me, so the punishment was concluded. She couldn't talk, and her cries had diminished into whimpers. Her supplications for mercy were unneeded. I knew she'd had enough. I could do anything, ask anything, demand anything—or everything. It was finished.

After I untied her, Carol was unable to move from the place of her captivity. I helped her up and held her in my arms as we both struggled to catch our breath. Now was the time for Carol to serve me. Now was the time to prove her obedience, her submission. Anywhere. Anytime. Anything.

24 HOURS IN HELL

February 1988

Alex has been my slave for several years now. I only have to touch her (with a certain attitude) and her entire body reacts sexually. I created that sexuality.

For our first visit to my new dungeon, I decided I would surprise her, and I didn't tell her what my plans were for our day and night together. I picked her up from her home. After driving a few blocks away, I stopped, grabbed her wrist and handcuffed her to the car for the rest of the drive. I wanted Alex to have the full effect of being a prisoner taken against her will. She fumed with rage while sitting slouched in the passenger seat, smoking, and proclaiming that this was completely unnecessary. After enough of her protests, I told her to "shut up" as I was tired of her complaints. The rest of the trip was silent. I could see the silence allowed her to fantasize about what was in store for her. This was good. Her imagination could be just as valuable to me in controlling her as my domination of her.

At our destination I parked in the garage. Leaving Alex in the car, I locked the outside garage door. Returning to her, I unlocked the cuff, and pulled her out of the car and over to the door of my cottage. I was indeed angry with her, and enjoyed the excuse to handle her roughly. Unlocking the door, I pushed Alex into the dark room, and

while she was off balance I dragged her to the fireplace. I locked the empty side of the handcuff to a ring firmly embedded in the mantle over the fireplace. I was pleased with this, the most difficult part of the trip had been completed. She still had her dark glasses on, and I could only imagine what thoughts were reeling through her head. I ignored her and left her standing in this dark unfamiliar place, while I closed and locked the door. She was a sight—indignant, beautiful, afraid—and you could see in her face all the possibilities she was imagining of what could, might, and (she prayed) wouldn't happen to her in that place for the next twenty-four hours.

I left Alex attached to the ring in the mantle, while I went around the room preparing for my scene. At the same time, I was explaining the ground rules. "Well, Alex, here we are. In the place you swore you would never enter. And look at you, locked to the mantle. Can't get away, and I am prepared to keep you here or wherever I put you, for the next twenty-four hours. There will be no escape. There are bars on all the windows and the door is locked from the inside with a key which is hanging around my neck. I'm sure you can imagine how difficult that will be to obtain. And don't try screaming. You know what that does to me. Besides your screams wouldn't raise too many eyebrows, there's so much noise in this neighborhood no one would notice your screams. Also, the place is partially soundproofed, so calling for help would be wasted energy, besides you don't want to make me angry."

When I was finished with my preparations, I disconnected the handcuff from the ring. Then, while tightly holding her, I firmly moved her to the table where I had a metal cuff ready to attach to her ankle by padlock. The padlock was connected to a 15-foot chain locked to another

ring in the floor. The chain was long enough to allow her into the bathroom. Once she was secured by her ankle cuff, I removed the handcuff and allowed her bathroom privileges.

"Don't get any stupid ideas. There's no lock on the door. I can come and get you anytime I want. So be quick." When I decided she should be finished, I went into the bathroom to find her sitting, waiting. I removed her dark glasses. I could see the fear in her eyes. What was she in for today? Gripping her firmly by the arm, I propelled her into the main room where I slowly and deliberately undressed her. Since I do not allow Alex to wear panties, and her stockings were thigh-high, there was no reason to remove her ankle cuff.

"For the next 24 hours you will not have any freedom, so just get used to the cuff. I have no intention of chasing you around the room or watching you climb into the rafters." The realization that she was truly helpless visibly shook her and took away the first layer of her resolve. I would enjoy stripping her, layer by layer, until she was submissive.

I led her to my bondage chair, sat her down and began buckling the straps that would keep her firmly bound to the chair. With each cinch of the belts, Alex gasped. When satisfied that she couldn't move anything except her head, I picked up the piece that would hold her head firmly in place and deny her the ability to see anything below her neck. While I was screwing the tray in place, she held her breath to keep from shuddering. When I finished, I noticed that her sex was dripping and her resolve had been completely stripped away.

"Didn't think I would get to you so quickly, did you? Just look at you. Dripping already." I smiled. She screwed

her eyes shut—the only way she had of closing me out.

"Are you hungry? Probably not, but you need your strength for the next few hours, and I've thought of everything. Lunch will be ready shortly." I busied myself preparing lunch, and brought it over to her on a tray. It was only then that Alex realized that I would be feeding her lunch while she was tied into the chair. Suddenly I could see the resistance begin to come back. Her eyes began to flash. She hates being fed. She hates not having control. However, it was amusing that she, being helpless, would consider resisting, even momentarily. But I welcomed that resistance. Not only knowing I would win, but knowing I could use her own energy against her to punish her further, I lifted the food to her mouth, and she clenched her teeth. My other hand went to her face and squeezed her cheeks together until the pain compelled her to open her mouth. She flung her head back and forth to avoid my hand but I held on. It was easy to win that round. She held the food in her mouth without swallowing, and I could see the battle going on in her eyes. She was struggling with a decision: did she dare spit the food at me or should she swallow it? Acknowledging this war, I said, with my no nonsense, teeth-clenched voice, "I suggest that you swallow that food *now*, young lady!"

She did. The rest of the lunch was uneventful. When the moments of hesitation returned, I reminded her of the gag with the feeding tube. "I would love to use it, Alex. You need your strength for the long hours ahead, so I am being kind by feeding you. Don't you appreciate my thoughtfulness?"

Her eyes gave me her answer: no. I smiled. She obediently ate the rest of her lunch, even though it was difficult for her. After lunch I played with her vulnerable

body. The chair I had strapped her into made any intrusion easy. The straps left very little skin exposed, but held her completely secured to the chair. A cutout in the seat allowed her sex to hang openly for play. I commenting about the "puddle" she was making under her chair, to which she responded with a shudder and moan. I moved the chair around on its wheels, thrusting it back and forth, making her more sensitive and pushing her further into a vulnerable headspace.

To change the pace, I untied her completely, but before removing the tray from around her neck, I put locked mitts on her hands. I allowed her bathroom time again, retrieving her when I thought she should be finished. This time I found her cowering in the corner of the bathroom like a frightened animal. Dragging her out of the bathroom and into the dungeon, I stood her in front of the cross. (Which is two beams in the shape of an "X" with cross pieces bolted top and bottom.)

I positioned Alex in front of the cross, and moved her to step up on the bottom cross-piece. I then attached her wrist-cuffs to the uppermost eye-bolts, and her ankle-cuffs to the bottom bolts, and proceeded to use belts to bind her to the frame. Starting around her waist, I pulled the first belt very tight. A shudder ran through her body. I tightened other belts around each thigh, very high under her bottom, to help support her weight, then around her lower thighs. Moans and sharp intakes of breath spoke to me of her susceptibility, and with each cinch of the belts, and each moan, my passions mounted. Continuing, I secured straps around each calf, then around her ankles. I did the same to her upper body and each arm, making her one with the cross. Her weight was completely supported by the belts, so I moved her toes off the bottom board. I ran my hands over

111

her body, checking each belt, retightening them as needed. The moans and quivers rewarded my labors.

The top of the "X" frame was hinged to the wall, allowing me to use a block and tackle attached to the bottom to hoist Alex up high, just about level with the ceiling. I then decided to lower her to a height that would allow me to stand between her open legs. My breath (or whatever else I wanted) could be felt on her most vulnerable spot. She cried, moaned, and panted. I enjoyed my control before moving her higher again. I left her there long enough to tidy up and further frustrate her by ignoring her few attempts at communication.

While lowering the cross, I used the action to throw her off balance. I would lower and raise the cross at my whim. When she thought it would finally touch the floor, I would quickly snap it up again; when raising it, I would allow it to drop a foot or so abruptly. Finally I let it drop to the floor with a thud when I decided it was time. I picked up my whip and walked over to her. She was expecting the whipping. But I did not strike her, I walked around, silently prodding her with the handle of the whip, before I spoke.

"Well, Alex, you knew we were going to have a scene, and you're right. This *is* going to be a scene all right, a *real* scene. A scene like you've never experienced before." My voice, laced with venom, spewed out each word. "You may never see me again after today. But when I release you after this 24-hour period, you will be changed. Our relationship is not going anywhere now, so I have nothing to lose. You've wanted a confrontation? You've got it. But, I chose the time and place, and *now* is that time. Confront me. Come on. In your fantasies you dance around, just out of my reach, taunting and tormenting me. Well, here is the reality, and you can't even speak. Aw, am I not

playing fair? I've learned from you how to play this game—change the rules, get all the advantage, then play. Isn't that how *you* play?"

With that, I raised my whip and brought down a hard lash across both bottom cheeks. Her breath was forced out with a groan. "Go ahead, confront me, bitch!" Again, another lash. "Alex, you're so brave on the other end of a telephone line, but what about now?" With the last word, there was another full strength lash and another gut-wrenching moan.

Crack! Smack! Whoosh!

"Where is your bravado now? Or are you only really challenging when you're a few miles away on the phone, making my life miserable. (Smack) Well, it's going to stop, now! (Slash) Yes, this is your scene, Bitch, but this is also your *nightmare*. And, most of all, this (smack) is (crack) my reality!" I began whipping in earnest. Her moans and cries became like those of a hurt animal, one with the sound of the whip, on and on. Eventually each breath was a sob, and my arm was tired. The energy of the anger I felt was being turned into passion. I wanted her, but "I" would have to wait. If I truly wanted this scene to change her, I couldn't think about my needs until I could see the change. I sat and watched her sob. I was satisfied.

As I carefully helped her down from the cross, she reached to hug me, a reassurance I would normally give her, but not today. I wouldn't allow her that comfort. I turned her to face away from me and firmly moved her toward the bed. Her legs were weak. She couldn't stand alone and fell across the bed. I left her there to recover. The upper part of her body was spread on the bed while her feet were on the floor. A perfect position for what I planned to do next.

113

I crossed her arms in front of her and tied a rope from one mitt to the other, drawing the rope ends around her and knotting them at her back. (Each mitt has a ring at the finger tip. While standing behind her, with her arms crossed, using those rings, running a rope between the rings and tying in this way, I can achieve a simple, restrictive bondage.) The tails of the rope that hung to the floor I pulled up tightly between her legs, through the cheeks of her bottom, then up to her arms in front, where I tied the rope around her crossed arms, insuring that each move of her arms would pull the ropes through her crotch and against her clit.

Putting my forearm between her legs, I lifted her onto the bed, turning her and adjusting her position into the middle on her back. Opening her legs and tying her ankles to each foot of the bed, I made her into an inverted "Y." Then I adjusted the ropes from her arms so they would hold her crotch lips open, exposing her clit. This sent tremors through her body with cries, moans and shudders. Taking my time I tied her to each side of the bed from her elbows, and by making a harness under her arms I tied her to the top of the bed as well. I wanted to eliminate her moving downward to lessen the tension on her legs, or rolling side to side trying to avoid anything I might like to do to her. It also prevented her from sitting up.

I made sure escape was impossible, turned off the lights and left. I went no further than the front house. However, I left her in the dark. Hearing me lock the door, and not knowing where I was, what I was doing, or worse, when I would return, was frightening to her. I left her there for about an hour, while keeping the intercom open and staying near its speaker. I had set it up for exactly this purpose. (I didn't want to return to a victim who had been harmed,

who had gagged, or had experienced some other terrible thing that I didn't do to her.) I made use of my time by making rice pudding for Alex, her most hated food.

Returning to the dungeon, I was rewarded by renewed sounds of moaning. I did not move to untie her, or even pay attention. I busied myself doing the dishes, straightening the place, and organizing myself while ignoring her pleas for my attention—I found them amusing.

The two-egg vibrator would be good next. It is simple: two eggs, each dancing at the end of its own cord. How perfect. They would just bump against her, constantly hitting each other, and they would drive her wild. I hung it from an overhead beam with a rope, making it just long enough to barely touch Alex's exposed crotch. Her eyes were pleading and imploring. She was incapable of speaking, but her eyes spoke volumes, and I knew she was begging for me to end this scene. But I wasn't ready for it to end. She needed to be punished, and it would take a lot more than this to do a proper job.

When I turned the vibrator on, Alex's moans turned into cries. So I gagged her. She was getting too loud, and I feared she might alert the neighbors. The eggs danced against each other and continually bumped into her exposed clit driving her crazy. I turned them to the slowest point so that she wouldn't be able to harden herself to them, and again left the room.

For the next few hours I alternately used dildo, vibrator, and manual stimulation to keep her on edge. I sat on her, used tit clamps, feathers, sharp pointed instruments, and a mild electrical shock/stimulating apparatus. I did not untie her for several hours.

Alex had no choice but to watch as I prepared dinner. I laid out a beautiful tray with a candle. I carried this to the

bed. She suddenly became aware of my intention to feed her in bed as I tucked the napkin under her chin. She fought as much as her bonds allowed her, and dislodged it. I rewarded her with a slap across her face. "How dare you fight me? Obviously your punishment has not been sufficient, so after dinner we will continue."

Alex shrank. I was ready. But I decided to wait—the pudding I had prepared for her earlier was ready, and would be an appropriate punishment for her most recent defiance. Although I had to remove her gag to feed her, dinner passed uneventfully. Several times I could see the conflict within her, she was entertaining thoughts of spitting the food at me. I guess better sense took over as she never quite got up the nerve. All I had to do was look at her, and she quickly swallowed. After clearing away that tray, I brought another. This one had a black gag with a rubber feeding tube in the center of the mouthpiece. It was sitting next to a bowl of rice pudding, and the tray was adorned, sarcastically, with a rose. "*No!*"

The sound exploded out of her. The look on her face was one of such surprise that I believe she didn't think the word had come out of her, however when she recognized it had, she quietly added, "Please?"

I silently picked up the gag, forced her mouth open, placed it in and buckled it around her neck. While filling the feeder I reminded her that all her bodily functions were under my control. What and when she ate would be my decision, not hers. And perhaps, if she were more obedient, she wouldn't be forced to eat the food she hated the most. Having said that, I calmly began forcing the pudding into her mouth. All she could do was choke or swallow. She swallowed. I fed her fast, almost the whole quart of pudding, but, wanting to see her obedience, I saved a good

116

serving to spoon feed to her, so she could really taste it. What power. I *loved* it! Without hesitation she ate every spoonful, especially when I told her there was almost another quart waiting for her. I would be delighted to bring it if she hadn't had enough or gave me any more trouble.

Before beginning my cleanup for the night I released her legs. She stretched and bent them, loosening the stiffened joints and enjoying the momentary freedom. Removing the vibrating eggs from the beam above, I slipped one egg into her, and quickly bound her legs together and tied her ankles to the bed so she couldn't move them. Then I shoved the other egg between her legs. I turned it on, and went about straightening, folding, coiling ropes, doing dishes, and seeing to all the other things required. Then I got ready for bed, sat and read a book and relaxed. All this time Alex was again being kept on a sexual edge, moaning, and fighting the bondage. I enjoyed her discomfort. It gave me pleasure to feel her frustration, especially since she had frustrated me so often in the recent past. It had been a good day.

Since it was close to midnight, I decided it was time for bed, and released her allowing her to think that I was finished for the night. Alex felt relieved. Each time I had released her previously for the bathroom, she would reach for a hug, and I would deny her the comfort. This time I held her, allowing her to feel my strength, and giving her a little of the emotional release I had denied her all day.

Alex readied herself for bed and came back to the room of her own accord, but then noticed the harness I had put on the bed. Words exploded from her: "I thought you were finished!" Almost before the words were out of her mouth she realized my purpose and cowered. I grabbed her, holding her tense body so that I could easily apply pressure

and hurt her, if necessary. I put the harness on her, and secured all the buckles. Putting her to bed I used the rings at the shoulders to tie her to the top of the bed. With ankle cuffs I attached her firmly to the bottom of the bed—it was built for bondage, of course. I placed her on one side of the bed and covered her with a blanket, then got in on the other side of the bed. At this point she began flopping up and down like a fish, trying to release herself, as the idea of sleeping in bondage was—and is—totally unpleasant to her.

I exalted in my power. I was so hot and so turned on by the day I began to masturbate, which caused Alex to thrash harder and more violently in her bonds, hissing with her need and desire to be between my legs.

Eventually she fell asleep—with surprising ease, considering the anger and frustration she felt. Or, maybe she just passed out. She continued flopping around even in her sleep, trying to release herself by movements she wouldn't have even attempted while awake. She did succeed, however, in keeping me awake most of the night. I eventually released her except for one wrist and her ankles. Since she sleeps soundly, she wasn't aware of her partial freedom, but did stop flopping.

In the morning, when she awoke, she was surprised to find me up, showered and dressed, with the same severe attitude as the night before. She asked that "it" be over. "Please, I've had enough."

"But I haven't!" I told her she could use the bathroom and that we would then have breakfast. Alex was disappointed, but obeyed. She asked that I allow her to feed herself. Silently, I led her to the "chair" and after attaching her, without resistance, I fed her. Reminding her if she were reluctant to eat, I would be happy to use the feeding gag, I did not allow the least hesitation. I fed her, then

announced that I had changed my mind about the twenty-four hours. I was not going to release her then because I wasn't convinced that she had learned her lesson. I could see the look of horror in her eyes. I refused her request for a bathroom visit.

"You will just have to wait until I'm ready for your bathroom break, and when I am, I'll tell you. Remember, your every bodily function is in my control, and you will just have to wait."

She watched as I cleaned up from breakfast. She was filled with anxiety, and had a full bladder as well. Finally I untied her, and allowed her bathroom time to freshen up. And this time when she was finished she returned to me. (To me this action was an improvement in attitude, as it showed less resistance.) I motioned her to lie down on the bondage table. She obeyed with little hesitation. Using the same straps and belts I had used on the cross, I bound Alex to the table. First I attached her mitted hands to the eye-bolts, then I put on 6-inch wide belt around her middle. That got a shudder. A second belt went around her knees—a gasp. Another around her shoulders elicited a moan. Nine belts in all mummified her. With each cinch of these belts her determination to remain strong dissolved, and with each cinch I gained strength. She cried out when I retightened each belt. Finally, the last unbound part of her body, her head, was to be held fast. I put a gag in her mouth and buckled it, strapping it not just around her neck, but around the boards that cradled her head. This kept her mouth full and prevented her head from moving even an inch.

Now, full of power, passion and anger, I delivered the lecture that was the motivation for this scene. The subject of this lecture was Alex—her attitude, her teasing, taunting, lying, conniving, demanding, etc. All of these are subjects

119

pertinent to our relationship. While lecturing, I brandished a cattle-prod. The first time I touched Alex with the prod she nearly jumped out of her skin. The sight of this weapon frightened her more than anything I had ever used in prior scenes. And, of course, that fear fed me. Periodically, I touched her thigh, arm or leg with the prod, and watched her watch my thumb intensely to see if that slight twitch would be followed by the searing pain that would tear her insides to shreds. It did, briefly, occasionally. But more often I would pull the prod away from her skin just the millisecond before pressing the button, and the effect was almost as devastating. The cruel buzzing sound the prod makes was a blast in our ears in that quiet room.

I played this game intently for about thirty minutes. For many more minutes I taunted and tormented her, sometimes with the prod, sometimes reaching for it, but always reminding her that it was available, and why I was punishing her with it. I wanted her to change—I was demanding that change. This was not just a little game, this was reality! From that point on, mental torture was easy, and bondage was minimal.

Bringing her back from that place I had flung her into was a gradual process. She had been punished, inside and outside. She had been stripped of her humanity. She had been completely reliant on me for everything, and bringing her back to life had to be done slowly. However, before allowing her complete freedom, I demanded that she kiss my foot—an act which, if it is not demanded, is easy, but when demanded it humbles her to the point that she is almost unable to obey. She immediately obeyed. She cried.

When I untied her it was eleven a.m., her twenty-four hours of hell were over.

I held her trembling body for hours.

HIS FIRST SPANKING

October 1989

The list held many offenses, some serious and some trivial. I smiled, then I noticed the line near the bottom of the account I had requested: "Sometimes I drink too much and then drive." The smile faded from my face as I looked at the young man standing, pants around his knees, facing the corner. He was trembling, and quite ignorant of the evening that lay ahead of him. He was unsuspecting of the strength I possessed, and unaware of the opinions I had about drunk drivers, unaware of the emotions that were churning inside me, and completely unprepared for the punishment that I was about to administer.

A few nights ago I met this very pleasant and attractive gentleman who had been seeking a rendezvous with me for quite some time. He asked a friend of mine to introduce us, and she did. He told me of his desire to be spanked, and that he had been searching for someone who had a desire equal and opposite to his own. I was impressed by his sincerity, his honesty, his vulnerability, and by the obvious respect he had for my authority. I also liked the way he approached me, much more imaginative than most. I wanted to spank this bright and courteous man who had the intelligence to wait patiently for me until I was ready to meet him.

In our conversation he revealed his need to cry, really to cry repentantly for his many wrong doings. He told me of his childhood filled with delinquencies that—much to his frustration—went uncorrected. For the last ten of his forty years, he had been searching for someone to "take him in hand." He was fascinated with the "over the knee" methods I described, and intrigued with the very idea of using the hairbrush. He also confessed that he had gone to some professional houses where he had been beaten severely until he was black and blue, but did not experience the emotional release he sought.

Now, this trembling recalcitrant was standing in the corner waiting. I moved close to him as I read the list aloud. When I came to the phrase "drink too much and drive," I allowed my displeasure to show through my voice and words. "What is this on your list? You drink and drive? I can't believe this! Don't you know the danger? Don't you realize you could have been hurt or even killed due to your incapacity to react suddenly to unforeseen situations you might encounter while driving? I'm surprised at you. This is really unacceptable behavior. I can't understand why you would do this. You are an intelligent young man, and there is no excuse for this type of behavior. I really can't believe you would be so irresponsible."

As I spoke—scolded—my displeasure began to escalate. "I can't accept that you would get behind a wheel in a state of diminished capacity. I can't believe you would do something so completely reckless. Well, believe me young man, you have done this for the last time!"

Taking Charles by the ear I turned him to face me. "I'm going to give you the spanking of your life. You have been careless, irresponsible, and stupid, and I am going to make sure you see the error of your ways before you leave

tonight. Now come over here, across my knees. Right now!"

Still pulling him by the ear, I walked him over to my straight backed chair, sat down, and flung him across my knees. While talking I adjusted him into the traditional spanking position over my knees. His hands on the floor supporting him, his bottom the highest point of his body, his pants around his knees. "You should be ashamed of yourself! I can't believe what you've done! I just can't believe it!" I started spanking him with my hand. I didn't hold back, my indignation was driving me, propelling my skilled hand down, hard, on his bare bottom. This was one lesson he was not going to forget, I would stake my reputation on this. He was trying to stay in place over my knees while I was working on his posterior, but his legs were thrashing about, eventually flinging his pants across the room.

Again, again, and again, the stinging swats landed on his reddening, squirming bottom. The air was filled with moans, little cries, ouches, and spanks. I could feel my energy building. My hand rained down relentlessly, and I continued long past the point at which I ordinarily would have stopped. I paused, grabbed the leg closest to me and put my right leg over it, pinning his leg under mine. I adjusted him closer to me and continued the discipline. "You are never going to be the same after I'm through with you tonight! Believe me, I will not tolerate this behavior! This will stop!"

He put a hand back to protect his bottom, and without losing rhythm I grabbed his wrist, pulling it into the middle of his back, holding him tightly in position. "You will *not* get your hand in my way. You are going to feel each and every spank, and believe me you will be a changed person

when I am through with you." I continued for well over five minutes working his vulnerable bottom, and I was breathless when I finally stopped my attack.

I lowered him to the floor in a kneeling position, drew him to me between my stockinged legs, and held him tightly while he heaved against my chest trying to catch his breath. When he had partially regained his composure, I said: "That's just the beginning, and that was only my hand. You have a lot more in store, so while you're waiting, stand in that corner, and don't touch your bottom. Hands to your sides!"

He was naked now, and his posture was that of a teenager, much different from when we began. I was beginning to make an impression, one he would never forget. While Charles was in the corner I continued my scolding. "I hope you are beginning to see the error of your ways. You know, Charles, you are a very bright boy, and I'm happy you realized that drinking and driving was a punishable offense. However, being irresponsible not only places you at risk, it also endangers those around you. I will not tolerate this behavior at all. Before you leave here tonight you will understand what punishment is all about. You will not only understand it in your head, but your bottom will be so tender you will have trouble sitting down when I'm through."

I approached him and stroked his hot bottom while speaking. A couple of swats reminded him how tender he had already become. "All right, Charles, it's time for the hairbrush. Come over here. Now! Across my knees, you know the position." I adjusted him to my liking, picked up the antique, ivory-backed hairbrush and began with a few preliminary swats. "Do you feel this? I told you, when I use my hairbrush you will definitely know you've been

spanked. It's one thing to think about it," I said—swatting hard with the brush to punctuate what I said—"but another to really feel it. I thought I would just give you a preventive spanking tonight, but I didn't know just how bad you'd really been. Unfortunately, now I have to use this brush to punish you for a terrible thing. This is because you have been a foolish delinquent. You've been thoughtless and irresponsible. You had better think twice the next time you pick up a drink. You had better think about the taxi you will be calling if you have a second drink."

The air rang with the unmistakable sound that only a hard, old-fashioned hairbrush hitting an unprotected bottom can make. The smacks were quickly followed by the moans, cries, and whimpers of the reckless miscreant across my knees. Again my indignation took control. I began to think about the example he was giving to his impressionable teenage children, and I continued to punctuate my words and thoughts with swats of the brush. My fervor accelerated when I thought of his children. I have children too, and I have trouble tolerating incompetent parents. I was going to teach this forty year-old father a few lessons that can only be learned at a disciplinarian's knee, no matter what the age. I began relentlessly thrashing his defenseless bottom. Words were unnecessary. I had a responsibility to get to his interior, to hold him (the man) in a time warp till I was able to get to the child inside. Moans and cries filled my room. His legs were thrashing about, and—soon enough—the sounds coming from him were not coming from a man, they were coming from a long neglected and undisciplined child.

I continued spanking him until his body became limp. (A sign of having reached the saturation point.) It was useless to continue right now, so I held him there, over my knees, scolding him, and rubbing his very sore bottom. "I can't

believe I have to spank you for this, such a stupid act. I can't believe you don't have more respect for both yourself and others. I am really ashamed of you. You know better. You are going to start thinking of the consequences of your actions, or you aren't going to be sitting very much. You are an intelligent young man and many other young people are watching your example. Are you giving them the right message? Or are you telling them it's all right to take your life and the lives of others in drunken hands? No! No! (Very hard strokes marked these words!) No, it isn't all right. No, I will not stand for this careless behavior."

The smacks I was giving him were slowly administered and quite hard. I was making certain he felt each one separately rather than allowing the strokes to build on each other. This was a lesson he would never forget! After rubbing and smacking for a few minutes, I once again shoved him to the floor, and he remained on his hands and knees, sobbing dry sobs. When he composed himself, I once again hugged him to breast, and pointed him to the corner. He knew the drill—hands to his sides, head in the corner.

Looking at his bottom I saw the purple circles made by the hairbrush, and knew I would have to bring him to tears quickly. I didn't want to cause too many bruises, but I needed to make sure he realized the error of his ways. I brought out my padded bench, one that he could lie across without discomfort. The only discomfort I wanted him to feel was that of the leather I would lay across his bottom. "Okay, Charles, come over here and stretch out across this bench. And you keep your hands out of the way. I'm going to strap your bottom thoroughly, and if you get your hands in the way, it will be a lot worse for you."

He did as instructed. "Now it's time to get down to

business. I'm finished with talking. I'm through with stroking your bottom. Now you're going to feel my wrath for your actions. This leather tawse is one of the more severe punishment instruments I have, and I am going to make sure you've learned your lesson. I hope I will never have to do this to you again! There will not be a repeat performance!"

With those words I began strapping his bare bottom. The tawse is a double thick stiff leather strap about sixteen inches long and one and a half inches wide, with a double tail. I was standing over him using my full arm swing with the strap. There was no doubt about it, this was no playing matter. This was serious discipline. "Have you decided to change your ways? I really mean what I say! This is one lesson you will learn and learn very well. I don't care how long I have to keep strapping you! I can keep this up for a very long time. You have been thoughtless, careless, reckless, and I will not tolerate your actions! You have endangered lives. Do you think you're learning your lesson?"

I continued strapping him with all my might. I became lost in my determination to chastise this miscreant, to convince him that I meant business. He began crying. His entire body shuddered with each sob. It wasn't just little boy cries, but sobs that come from deep inside—from the core of the man who had been thoroughly punished. But the pain was secondary to the humiliation and disgrace he felt for disappointing me. His crying continued long after I had stopped and had taken him in my arms, embracing and comforting him. Words were not necessary. I somehow knew he would never put me in the position of having to repeat this punishment—and I haven't had to.

MAGGIE

July 19, 1990

I was lying in bed watching television. It was getting late, and I knew that Alex was due to call. Sure enough, the next time the phone rang there was a familiar voice on the other end. However, the conversation was odd. She opened with, "Hello, are you Nan?"

I started to say something because I wasn't sure what she was trying to do, but I thought better of it and let her continue. "Yes, I am."

"I read your ad in the Wishing Well, and I decided to call you," the voice said. My ad in the Wishing Well? That had been years ago. I remembered the ad.

Looking for a special woman to fill my desires. I am married, not interested in a Ménage-à-trois. I need a woman to make me complete, but she must submit to my will, as THAT is what turns me on.

"Tell me about yourself," I said, trying to hide the questions in my voice.

Alex—as Maggie, someone who didn't know Nan—and I talked for a little over an hour. Our conversation covered her curiosity about the scene, her experience or lack of it, likes and dislikes, and fantasies. She said that she would call back at a later date.

I hung up the phone, smiling to myself, and started to

evaluate the conversation in my mind. The phone rang again a few minutes later, and its jangle interrupted my chain of thought. It was Alex again, this time as herself. We acted as we usually do at night, with no mention from either of us about the earlier conversation. However, before hanging up, Alex told me she couldn't see me on Friday "something had come up." I told her that it was all right. Through the course of the week there were a number of calls, both from my lover, Alex, and from Alex as Maggie.

We set up a date to meet. Alex and I had planned to spend the weekend together. It was to be our first time alone together in four months. Alex had been in Europe, and I had been in South America. Now, instead of spending two days with my lover, I would be spending one day with Maggie, and one day with Alex.

During one conversation Alex told me that she knew about my chats with Maggie. I told her about the calls and about the young lady I would be meeting. Maggie, it turns out, was a friend of hers, and she was really rather jealous that I was dumping her—my lover—for a stranger.

As the week rolled by, we both got more and more caught up in the game. Soon, it was hard for me to tell which one of us was the spider, and which the fly.

Maggie and I had our last conversation Thursday night. "What would you like me to wear?"

"Skirt, garter belt and nylons, without any panties."

"What do you mean, no panties? I can't go out that way."

"Sure you can. And what's the big deal? I'm not asking you to come over naked."

She tried logic on me. "Why does it matter, anyway? I'm not going to be doing a scene with you?"

"You asked me what I wanted, and I told you."

"Well, just so you'll know in advance, I will be delighted to comply with most of your requests, however, I will definitely wear panties. I'm not that submissive," Maggie said firmly. I never conceded to her arrangement.

We continued our conversation and agreed that all we would do was meet and talk. She had heard about me by my reputation, and didn't want to do a scene. She just wanted to get to know me. Every fiber of my being knew that was a lie, but I agreed, knowing full well that once I had her alone she was going to get the scene of her life. She would have the thrill of playing with a new person, and still be with someone she knew and trusted.

Friday morning I got up early and went down to my playroom, knowing that my slave was going to be delivering Maggie. Noon came and went. Maggie was late. At 12:30 there was a knock on my door. I answered it, and my slave and Maggie walked in. My slave excused herself after a quick trip to the bathroom, and this 'stranger' and I were finally alone. She looked around briefly, and we began chatting. "The traffic was just terrible on the way down. . . I guess from the fire. Sorry I'm late."

We continued. "You have a great place here, Nan."

"Thanks. I've enjoyed it a lot." I invited her to sit down, and we continued the small talk. I asked a lot of questions about what turns her on, her experience, her fantasies. Everything I asked was answered by a "no" or "I can't tell you that." About the only thing that I could get out of her without a lot of digging was that her experiences consisted of scenes scripted by her with playmates that she could control. Although she found them exciting, she said they hadn't been very fulfilling.

We were seated fairly close together, facing each other. I leaned forward and took her knees in my hands. When she didn't pull away, I ran my hand gently up her legs to see if she'd complied with my request. "I told you I'd wear panties," she said as she pulled away from my probing hand.

I continued talking, changing the subject. Then, in a non-threatening manner stood up straddling her knees with my legs. She didn't resist. I then clenched my legs together, imprisoning her knees, and we continued the conversation. Soon I leaned forward, pinning her wrists to the arms of the chair. Still no resistance. It was time to start the game. I rocked the chair backwards.

"Don't do that." Her reaction was immediate. I continued, rocking her back further. "You'll break the chair," she said in a breathless manner.

"Don't worry about my chair."

She couldn't look at me. She leaned forward to retain her balance, holding her head down. I heard her breathing hard, and continued rocking. I took advantage of the disorientation I knew I was causing by letting go of her wrist and reaching into my bra with my right hand to get a set of handcuffs. She tried to pull away, but I've played this game before. I locked the handcuff on her left wrist. It was easy to pin her arm around to the back of the chair but she struggled harder when I grabbed her right wrist to attach the other cuff.

"How dare you?" She was indignant. Silently I rocked the chair again. "Nan, I don't want to play," she said. I smiled. "Nan, I don't want to play. You told me that's all I would have to say and you would take me home."

"I lied!" Her body visibly reacted to this sexually.

"You. . . you *can't* do this."

"Who's stopping me? You obviously came here looking for something you've never had in your life, someone to dominate you. Someone that you didn't program. And here we are."

"No, no," was all that she could utter. I knew she had become putty in my hands. I took her hair, and pulled her head back so she would have to look up into my face. I had heard her mutter "Bitch" a couple times.

"Go ahead, say it out loud." I slapped her. She didn't say anything. I repeated, "Go ahead." Again, I slapped her. "Say it. Bitch! (Slap) Isn't that what you said? (Slap) Bitch? (Slap) Say it! (Slap) Oh, so now you can't? (Slap) Well, yes, I am a bitch, and don't you ever forget it!" Another slap.

I pulled her out of the chair by her hair and led her to the swing. She stepped up on the six foot long board. I released one hand, and locked the cuff to the chain on one side of her. (These chains connect the overhead beam to the board on the floor, making it a swing, but right now it was temporarily fastened to the floor so it wouldn't move.)

It was a struggle to remove her clothes, but in her position there wasn't a hell of a lot she could do to resist me. It took me a minute to retrieve leather cuffs and two padlocks, which I used to properly attach her by wrists and ankles to the giant swing. I stepped back to admire her near-nakedness. (I had left her in garter belt, nylons and high heeled pumps.) I took out fifty feet of rope and fashioned a rope harness around her body. Then I began weaving cords from the harness to the chains on each side, making her a fly in the center of the web. While I worked, she made several snide comments about my work in progress.

"Your ropes aren't straight, I thought you were a

perfectionist," she taunted. I was tempted to squash the insect caught in my web, but thought better of it, and backhanded her instead.

"Shut up!" I said through clenched teeth. She did. After finishing my project, I removed the boards that held the swing securely to the floor. Without the bracing it could move freely. She was startled. I played with her imbalance for several minutes before blindfolding her.

Once she was plunged into a world of darkness, I continued my play for a few minutes. She reacted sexually many times, but not violently. I took a few steps backward and watched her as she finally shook her blindfold loose. I said nothing. She watched as I picked up a specially prepared cookie, one laced with pot to increase her paranoia. (Alex had given me the pot for these cookies months ago, but Maggie was startled when I produced them.) I brought it to her mouth. She clenched her teeth. I squeezed her cheeks until she couldn't stand the pressure and she acquiesced, opening her mouth. I shoved in half of the cookie. I could see the wheels turning in her mind as she struggled with the idea of spitting it out.

"You'd better think about it before you do it." In my best no nonsense voice, I continued: "I'm prepared to punish you in a way you will never forget." From the doctor's bag in my closet I retrieved a four inch needle and held it up to her face. She tried to recoil from the object in front of her, which wasn't easy, tied in a web of rope to a moving object. "It would be my pleasure to pierce you, plunging this needle through your nipples, clit, or for that matter anywhere I desire. Now, just do me a favor, spit out the food so I can savor, without guilt, my amusement. Go ahead. Don't you want to?"

She began chewing and swallowing immediately.

134

"OK, OK, put it away. I'll do it, just put that away." She spoke with her eyes tightly closed, her head turned away. I kept the needle in front of her face with one hand as I instructed her to open her mouth. I put the other half of the cookie in her mouth. When she finished that mouthful, I shoved in another. I laid down the needle and gave her water to wash down the crumbs. I allowed her to finish swallowing, then continued.

"I'm very eager to have a reason to use this needle on you. Just push me the wrong way or disobey me, and I won't hesitate for a moment." She was convinced.

Now that Maggie had been properly traumatized, I needed something to cut her out of the spider's web. I found my straight razor in a drawer, swung it open and began cutting the webbing that held her to the swing. She tried to draw away from me. I didn't know if it was from the fear that I would cut her, fear of what was going to happen next, or if she was wondering what else I might do with that razor. Finally, attached to the swing only by her wrists, she stepped off.

"Did I tell you to get down? You get back up there this instant!" Before all the words came out of my mouth, she was back up on the swing where she stayed until I told her to move. I finally released her wrists, steered her to my slatted bondage-table in the center of the room, and told her to "get up." I thought she was following my orders, so I turned my back to reach for the long straps to bind her to the table. Out of the corner of my eye I saw she was getting off the table on the opposite side, apparently intending to use the table as a center to play *keep away*.

Moving back to the table, I quickly drove it into the wall. With anger propelling me faster than usual, I went around the table to her, grabbed her by the arm and hair

and thrust her physically back up onto the table in one fluid motion. "How dare you defy me? How dare you?" I spat out the words, I was angry. "Just who the hell do you think you are, and what kind of games do you think I'm playing?" My eyes were flashing with the emotions of the moment. "You are here for the duration, and I am going to make sure you never forget this day. Defy me? Go ahead, try it. You will live to regret it. This is not some little competition to see who wins here, this is life. This is your life, and baby, if you want to survive, you'd better learn to obey the rules—my rules!"

I was holding her hair so tightly I could see the stretch on her forehead. A slap or two added emphasis to my words. She muttered, "OK, I'm sorry. OK. OK, I won't."

I tied her wrists to the table. I didn't think she would move, but I wasn't going to give her another chance. I grabbed a handful of straps off the hooks on the wall, and dropped them all across her body. I began choosing the proper ones for her arms and legs, fastened them, furiously tightening the strap around her waist. She gasped, her body betrayed her. Ever so slowly, I finished my project. Her legs were spread apart, and she was securely strapped in place. Besides the legs, I had strapped her hips, her upper arms and her shoulders. I buckled and rebuckled each strap, and each time I touched a strap, I cinched it a bit tighter and listened to her gasp. I heard her muttering, "I am not afraid. I am *not* afraid. I *am not* afraid."

"Oh, you aren't? You should be!" I laughed. "You're so afraid you're trembling, and you have good reason to be. This scene will be like nothing you've ever experienced before. I have hours and hours. And I know, if you've been told anything about me, you've been told I never stop until I have completed what I began." With a touch of

sarcasm I added, "Now who do you think will tire first?"

I took my time wrapping a roll of cotton spandex, five inches wide and three yards long, tightly around her head, leaving only her nose open. She continued gasping and mumbling to herself, "I am not afraid, I am not afraid." But the mantra wasn't working.

I knew she could hear me. She would stop murmuring whenever I talked to her. I ran my fingers up and down her body, sometimes very lightly, sometimes pinching, and I kept repeating that we had hours and hours, reminding her I would stop only when I had achieved my desired result. Only I knew what that result was to be.

Now that she couldn't see, it was time to start the head game needed to shatter her defenses. A little dollop of self-heating shaving cream from my doctor's bag would be the perfect instrument. "Is it warm yet?" No answer. I leaned over a little closer to her head and repeated my question. "Is it warm?" I heard a mumble through the cloth that I didn't quite understand. After asking the question several more times, she felt that her private parts were actually getting warm. Of course, they were.

"Yes. Yes, what . . . ?" She was incapable of finishing a thought.

Time passed. The air conditioner was at full blast, but the room was still warm. I watched beads of perspiration forming on Maggie's neck and chest. I didn't want her to suffocate nor did I want her attention focused on the fact that she was hot, so I removed the spandex wrapping and tossed it aside. I could always come back to it later. She blinked a few times from the sudden light, and I allowed her eyes to adjust. She craned her neck to see what it was I had rubbed into her.

"What is that? What did you put on me?"

"Is it hot?"

"Yes," she hissed.

"It is a cream to desensitize your skin. I don't want to hurt you too badly. So the doctor suggested I use this cream. When it gets hot, it begins working." I smiled.

"What . . . What are you talking about?"

After pulling on rubber gloves I picked up the hypodermic needle. She had obviously forgotten about it, at least momentarily. She screamed. The fluid in the syringe let her know I wasn't joking. I was now playing on her worst nightmares. This time she couldn't wake herself up. The cold touch of steel forceps reminded her this was real. I clipped the vaginal lips out of the way of her clit, and swabbed the area with alcohol. Very ceremoniously, I held the needle up, and with gloved hand tapped it to remove the air bubble. I squeezed to expel a small amount of liquid. She watched me intently as I brought the needle down and touched the place I intended to pierce, just under the head of her clit. Her scream was so intense I decided it best to gag her. I did. She screwed her eyes closed, and with muffled screams, she acknowledged each time I touched her with the needle. She couldn't look.

Knowing she couldn't look, I pulled a sharpened wooden skewer out of my pocket, swabbed it with alcohol, and firmly jabbed it to the place I had chosen for her to think I would pierce. She started panting and screamed again, but held herself motionless. In a very tender manner, I again wiped her with the alcohol swab. Having pricked my finger beforehand, I showed her the blood stained cotton to validate her injection.

I leaned over the table, bringing my face very close to the target area, and studied her very closely, then began a carefully constructed monologue. "Oh, Alex. . . ."

I had to be much more careful to remember who I was with. Maggie! But she was too absorbed in the scene to notice. I continued, "You should see how big your clit is. It is so big, I've never seen anything like it. The doctor was right. I'm so glad he suggested I inject you with this fluid. It makes you so big—so big! I don't think you're ever going to be your normal size again. I can't believe it! Wow! You are so hard, and so wet. Is it tender?"

"Yes, oh yes, please, please." She was convinced. Her terror had mounted to the ultimate. I had broken all the boundaries. Now I was truly feared.

I placed a small vibrator between her legs, just touching her clit. Making sure it was turned to the lowest speed, I left her alone in her bondage and frustration. She was so sensitive the slow vibrations made her even more tender. While she was in this immobilized state, I was relaxing on the bed in the darkened room. As her moans became louder, I became more excited, and started masturbating. As her moans grew louder, my intensity increased. It was wonderful.

Before releasing her I touched her, softly, startling her, but that little touch allowed her to cum. When I finally released the belts, she lay there unable to move. Lifting her to a sitting position, I gently brought her to her feet. For a brief moment, she stood embracing me, then collapsed. She climaxed so violently that she could not stand. I hugged her, and she held on to me for dear life. I walked her over to the door and released her to go to the bathroom. When she finally emerged from the bathroom, I sat her in the center of my bondage bed. I cuffed her, and crossed her arms in front of her, tying a rope to run from the cuffs around to her back. Her ankles were attached to each corner of the bed so she looked like an inverted Y.

I took my time filling two enema bottles, hanging them from the beam over the bed in the middle of her body. The tube from each bag was attached to a valve, each with an off/on switch. From one valve came a long hose which ended with an enema nozzle, the other to a gag with a rubber bit through which the hose extended three inches. All the while I took my time, slowly putting everything in its proper place so she could get the full visual effect of each item before it was used. I put the rubber gag in her mouth and buckled it behind her neck. I checked to see that the flow was proper, and worked correctly without choking her. Then, I lubricated the bardex bulb, and lubed my finger as well. (The Bardex is a hose and bulb, sometimes two, which is inserted into the anus and inflated. It allows water to flow through it and into the rectum and cannot be dislodged.)

She tightened up. I attached her ankles to the pulleys overhead, and pulled her legs up so her bottom was elevated slightly above the bed. I inserted my finger. She struggled, and clenched, but I succeeded. Finally she relaxed, and I inserted the bardex, inflated both bulbs, and inserted the enema nozzle into the proper hose of the bardex. Standing at her side, I opened the valves, adjusting the flow of each. She began swallowing fast, her eyes communicating her feelings of fear and apprehension. I reduced the flow to her mouth so she wouldn't have to think so much about swallowing, freeing her to think more about the water going in her rectum. Occasionally I would turn off one flow and increase the other, back and forth, until her body was swollen with the two bags of water.

At times I directed her attention to the visual of water running through the clear pipes. Her eyes would widen with concern and alarm as well as awe, but she was unable to

140

tear her attention away from the flow. Suddenly, with a shudder, she would squeeze her eyes closed and gasp, moved by the effrontery of my assault.

Over the course of a half hour both bottles emptied, and I removed all tubes and ropes. She lay there, touching her swollen stomach in astonishment. Her usually svelte body had become engorged with the tremendous amount of water. Her eyes betrayed her amazement at her predicament. She lay there for minutes, feeling her stomach, trying to move, but unable to bring herself to move for fear of losing what little control she had.

I had to practically lift her off the bed. Once standing, she stared down at her now "pregnant" torso, finally accepting the fact that I controlled every cavity of her body and what went into or out of her. I allowed her bathroom privileges to relieve herself. While she was relieving herself I laid out dinner. She would be ravenous. Drained, she returned. During the meal, conversation was light, and the "Maggie" facade was kept up. I wasn't supposed to know this woman, so we both asked a lot of questions, and I was surprised at the truthful answers I received. In fact more truth than when we first met.

It was late when we finished dinner, and I put her into her last scene. Using all four pulleys in the upper corners of my bed, I attached her limbs and lifted her off the bed. She kept her body rigid, and the tension pulled her abruptly back into the scene. (She had smoked a joint after we ate, which enhanced her paranoia, as *that* is her scene). I kept her that way until—no longer able to hold her body stiff—she dropped her bottom onto the bed. I pulled her until she was completely suspended over the bed. I now had her in the perfect position to torture her further. I used my tongue very lightly on her engorged clit. It was as hard as

a rock, and very sore from all the actions of the day. I brought her to orgasm, over and over again. So many times that with each cum there was more pain. She begged and pleaded for me to stop. When I did stop, she cried. I smiled, and did it again.

End of first day.

THE PILL

October 1990

She had it. I wanted it. It was as simple as that.

Alex luxuriated there on the bed, smoking her cigarette with a taunting, infuriating attitude. She was succeeding in her plan: to challenge me, but in a playful way. She had a way of provoking me to do my worst which I couldn't ignore. This alluring creature was confident that she could keep her little secret as to the location of the pill, the pill that I would use against her in a future scene. Such defiance I couldn't dismiss. I felt like a fox with the hen dancing in front of me, all the time laughing and chanting "you can't catch me, you can't catch me." This was a delicious temptation.

My intention had been to give her an enema, she had seen the equipment hanging in the bathroom, warm and waiting. She knew she was going to have to work very hard to divert my attention from that desired goal. Her usual procedure would be to try to seduce me into forgetting my plans. And for this I was prepared. We were in New York at Dressing for Pleasure, and had already attended the event, and been the focal point of several parties, and she presumed I was all played out. However, that was not the case. I may have been tired, but my fiendish needs had not yet been fulfilled, and now she was pouring oil on an

already smoldering fire.

I laughed as I moved, and quickly positioned myself astride her reclining body, sitting on her, placing my weight directly on her crotch. Her movement was minimal, she really wanted me there. I took both of her hands, lacing my fingers into hers. I was careful to be gentle with her right wrist as it had been injured, and I didn't want to aggravate a possible problem, but I was certainly not averse to creating a new one. Slowly, while speaking, I began to force the fingers of her left hand back, causing her to readjust her position to accommodate the pressure.

"Well, now, Alex. I realize you can't have marks on your ass, because of the show you're in right now, but I can still cause you pain, and the only marks will be inside of you. Tremendous pain. And, at some point, you will decide to give me the information I want. See what I mean?" While speaking I held her hand pressed back and occasionally put a little more weight on her fingers to punctuate my words. Then I released the extreme pressure, while still keeping her hand in position, to allow her to reply. We were both laughing at this game.

"Ow . . . oww . . . ooowww. . . ."

"This is just a beginning. You're pinned and can't move away from me, and you of all people should know when I want something, I get it." We both laughed. We were playing at this point. She was laughing at my audacity. I was laughing at her naivety in thinking I wouldn't really hurt her to get the information I wanted. At this time I wasn't really hurting her, but this was just the beginning. "Where's the pill, Alex? Why don't you want to tell me? You want me to stop, don't you? You don't want me to hurt you, now, do you?"

I started the pressure again, and continued to speak.

"Really, you know I have the advantage. I'm much stronger than you. Don't you want to tell me? I suggest you tell me, Alex. I can make this much worse, like this." I applied serious pressure, and I felt her body respond. It was not the response I anticipated. She was cumming. I couldn't believe it. I knew I was causing her pain, and instead of resisting the pain or surrendering because of it, she was using the pain and responding to it sexually.

I watched her. The smile had faded from her face, and she was slowly slipping into that place where I take her during an intense scene, after she has smoked pot to create the paranoia. However, she hadn't smoked today. Her eyes were rolling back into her head, and she started cumming again when I increased the pressure on her wrist.

"Oh, Alex, look at you. I can see what's happening. Your tongue is beginning to swell right now. Feel it? It's filling your mouth. Pretty soon you won't be able to speak. Ah, yes, keep your mouth closed, that way your tongue won't jut out so quickly." I watched her intently. My silence further propelled her into that special place only I can take her. I was feeling the rush begin in my body as well. When she loses control, I get stronger. I could feel that energy beginning to flood my body.

"Open your mouth now, Alex. Yes, let your tongue have its freedom." She clenched her teeth together, not wanting to obey me, shaking her head "no." I could see the battle going on inside her. I enjoyed watching the process. I knew I could force her to open her mouth, but it was much more fun to coax her tongue out. I kissed her, using my tongue to entice her to open her lips. She did, and I slid my tongue inside her mouth, causing her to open wider. My kiss was disarming, and she responded briefly with her tongue before quickly retreating. I continued, and my tongue began to

145

touch hers, just on the tip. I played this little game of touching and withdrawing. With each maneuver, she would bring her tongue a little closer to her lips, and eventually I was able to suck her tongue into my mouth. I removed my mouth and grasped her tongue between my fingers.

"That's better, Alex. You see, I always win. You have no strength to withhold yourself from me. That's a lesson you will learn, eventually."

She screwed her eyes shut and began to shake her head again, but couldn't pull her tongue back in. "Oh, Alex, it's *so* hard—just like your clit." I began to stroke her protruding tongue. "It looks like your tongue has become another clit. See, you can cum when I touch you." She responded by orgasming while I was touching her tongue. "And now your clit is beginning to take over. Your body will become one perfect sexual organ. I will be able to touch you anywhere, and you will cum. And now your brain will begin to disconnect from your mind, and you are going to find it difficult to speak, no matter what you want to tell me, it will be impossible. Watch. See, when I cause you more pain your ability to think will be further impaired."

I pressed hard on her hand, she responded with a cry and a severe shudder originating from her crotch. The spasm continued as long as I continued the pressure. I was fascinated. This was a new type of domination. No ropes, no accoutrements, only my mind and my will against hers. "Alex, tell me, where did you hide the pill? Where, Alex? Where *is* the pill?"

I could see her trying to focus on a thought. She was straining, but couldn't actually formulate it. "Oh yes, you probably would like to tell me now, wouldn't you, but you are incapable of speaking. Your brain isn't attached, is it.

It must be terrible. You can't tell if you are telling me what you are thinking, or just thinking it. Can you? Oops, not yet! No, no, no. I'm not ready for you to tell me yet."

I quickly slapped my hand over her mouth the moment I saw her attempting to form a word. I didn't want my fun to stop now, not yet. That would have been too easy. "Oh, Alex, just look at you. You poor little thing. You can't seem to think straight, can you? You are trying to tell me something, and then you think you have, but you haven't. Oh, you're so confused." I continued my running commentary, anticipating her reactions, telling her how and why they were happening. With each disclosure she became more immersed in the spell I was weaving.

When I looked away from Alex, I realized it was dark outside. I had been playing this game for over an hour. She was my puppet now. I would tell her what to feel, and she would feel it. The power I had at this moment was what I live for. It's what makes me feel alive. "Well now, Alex, are you ready to tell me? Tell me where the pill is. No! Don't tell me. Remember, you're not supposed to tell me. Tell me, Alex. No! You can't tell me. You *must* tell me, Alex, you don't want me to hurt you any more, do you? Oops! Stop! Don't tell me. No, no." Now I began to intensely scramble her brain. I demanded that she tell me the information, and then, as soon as I could see the thought beginning to formulate, I would stop her. She would clench her teeth together, a strenuous attempt to keep the words inside, and then I would, once again, demand that she answer me.

Her confusion was amazing. I continued this game until she had trouble remembering whether she was supposed to tell me or to keep the information from me. She couldn't reason, she couldn't concentrate to complete a thought. Her

frustration continued to build until it overwhelmed her, and a sound, a wail, came out of her from a place so deep inside that it didn't sound human. It was like a sound from a wounded animal. This physical exertion released her momentarily and allowed her a glimpse of her reality. She was able to momentarily connect with her brain, and before she lost it again, I repeated my question. "Where's the pill, Alex?"

It took her a moment before she could answer. "Box."

"What? What did you say?"

"In . . . the . . . box."

It was hard to understand what she said. Her words were hesitant and soft. She repeated her answer more clearly, and as soon as she realized I understood her words, her body collapsed as though it had been blown up and now deflated. I had taken all her spirit. The situation that she had been steeling herself against was over, and she was utterly depleted—spent.

I allowed her a moment to realize what she had done before answering her. "I knew you would tell me, Alex. I just didn't know how long it would take." I smiled. "That wasn't so hard, was it? It would have been better if you had told me of your own accord. It would have been so much easier on you. But I don't mind, you gave me an excuse to hurt you. And you know I love to hurt you, Alex."

I released her hands. She groaned when she moved her wrists. "Does it hurt? Aw, that's too bad, Alex, but as I told you, when I start something, I won't stop until I'm finished." I turned her over on her stomach and stretched my body out on top of her. Alex welcomed my weight and her sexual excitement began to swell again, convulsing with orgasms. I remained on top of her until she was calm, then

I lifted myself off her. She was compliant and remained there while I brought in the full enema bag and hung it on her bed-frame.

I sat on the bed with one leg over her back and one over her legs, and began to massage her ass. She started to moan, but didn't seem to have the strength to respond as usual. Gently, I opened the cheeks of her bottom and carefully slid my lubed finger in. That brought her back to life, and she began to gasp. Quickly, while holding my legs heavy on her, keeping her in position, I removed my finger and skillfully forced the lubed bardex into its place. I had to wait for her intense writhing to subside before I would inflate the balloon inside her.

I could feel the power surge through my body when I inserted the bardex into her ass. This is an act of such invasion, such lewdness, that once executed I feel this torrent of power surge through my being. It's indescribable. It may be like a narcotic circulating through my bloodstream. It energizes me. It makes my heart beat harder and faster. My clit begins to throb. My hands shake.

I wanted to fill her until she was ready to burst. I needed to inhabit her body, wanted her to feel me. My dominance becomes so dynamic at times like this that I must pause to interrupt the spell so I can maintain control over it. I must control myself to maintain control over her.

Once I was composed, I inflated the bulb outside her, and then the one inside. She gasped. Her breathing momentarily stopped, and I deflated the bulb inside only to reinflate it. I wanted Alex to feel me inside her before I flooded her intestines with warm fluid. I attached the enema hose to the bardex and released the clip that holds back the torrent of water that is ready to fill her loins.

She felt it immediately. I watched her body react to the

invading fluid. She began to undulate. Her body both welcoming and despising the assault. She could feel me inside her. I was filling and stretching her entrails. I was ballooning her stomach. I was permeating her being, and while doing so I was invading her core. That is where I wanted to be. That is the ultimate power I crave. To fill her and possess her, so that she is incapable of thinking or feeling anything other than what I allow. I had succeeded.

DIANA & GINGER
OBSERVE A SCENE

July 1991

This night was different. I had not had a scene with Alex for quite some time, and both of us were more than ready. However, what made it different was that two women would join us tonight. They were both tops, and both interested in Alex. Diana is Alex's buddy, and had known Alex only as a top at the Vault in New York. Of course, she was familiar with Alex's strong-willed personality in her everyday life, and it was difficult for her to imagine Alex as submissive or broken. That's why she flew in from the East coast to witness this scene. And Ginger, a local dominant, was so fascinated with Alex's description of me and our scene that she wanted to see this transformation for herself. Most people who know Alex have trouble believing that she submits to anyone.

I was ready, but I did not have a plan for what I was going to do. I only knew I had to *take* her. I had to take her to a place where I could knock her out of the apathy which had been overcoming her for the past couple of weeks. But not only that, I needed to control her in a way that would punish her. I needed to feel that intensity of passion that would change her and stimulate me.

We were there, waiting for her. She came into the

dungeon with a more than imperious attitude and headed directly for the bathroom. I knew she was hiding her fear and anxiety. She was sexually charged, but didn't want to give into me or her needs, so she would fight harder to maintain control in front of observers. When she reentered the room her expression was softly challenging, far from the usual stone-faced glare of confrontation. I walked up to her, stood toe to toe and said, "I'm ready for you tonight. Yes, more than ready."

"You are? Why's that?"

"It's time. Tonight is my time. We're going to have a little attitude correction tonight. You will be different when you walk out of here. Trust me. That is, if you can walk." With that, I started to caress her breasts. She shied away. I told her it was time to smoke her joint. She again was softly challenging, with the attitude of "Oh, yeah," to which I firmly replied "Yes!" I took off her glasses and wristwatch. At this point my adrenalin began to pump.

She took a few drags on the joint, keeping her hand close to her mouth, possibly anticipating my plans. I put my hand firmly around her throat. I saw her eyes soften and her resolve slip a little. I instructed her to take another drag, and quickly placed my hand over her mouth pinching her nose so it was impossible for her to exhale the drug. I held my hand in place for around thirty seconds, until she started to struggle, then I released her. It was starting. I was slowly taking control. I could feel it surge through my body.

It's interesting, this exchange of power. It's as real as though it were a package she could hand me. I make a demand, she resists, I force, she capitulates, she gets weaker, I win. I become stronger.

I removed her clothes, leaving on her garter belt, stockings and shoes. Moving her to the "X" frame, I helped

her mount it, facing away from me. Then I strapped her firmly to it and attached the hoist. With each cinch of the belts that held her against the wood, she exhaled audibly. She was holding on to her resolve, determined not to show her vulnerability to me or our guests. But I knew what was happening to her inside, and she couldn't hide that from me.

I began elevating the frame which held Alex tightly, and raised it up till it was at a 90-degree angle from the wall. I walked under her, observing her reactions. She was above me, suspended in air. She was shaking. I could see her eyes darting around trying to find something in her line of vision that she could concentrate on to help her maintain control. But it was impossible, her sex was taking over. I could see the swelling lips of her cunt and decided to use her own sexual energy to my advantage.

I placed a magnet on each side of her labia lips and one in the middle. These magnets are very strong and hold together tightly enough that I was able to hang a fishing weight from them so she could feel and see the throbbing of her clit. The weight hung down about 5 inches from her body, and looking down she could see it swinging. Every time her clit pulsated, the weight on the string would swing. I played with the weight until I was certain that her mind and her clit were beginning to fuse together. Soon she was begging for its removal. I answered by continuing to vibrate and oscillate the weight, and then added more weight to it. She was gradually releasing her control, and forgetting everything and everyone in the room, concentrating on nothing but her need, her clit, her vulnerability *and me*.

"This is all that matters now, Alex. Your sex and my control. You want me to remove it? Hmm? Well, I'm not ready yet. You see, I'm the one to be pleased and satisfied

here. I have control. Think about it. You are going to be used by me tonight. That's what I want to have happen here. It may take some time, but I'm prepared to spend the night here with you in my dungeon, under my control. Watch. Go ahead, look! You can see your clit throbbing. Look, you are making the weight swing. I'm not even touching it, now. However, I can make it worse. Watch, Alex. Look."

I continued my monologue until she was violently shaking her head, trying to rid her mind of my words. When I felt this had gone on long enough, I removed the magnets and began to lower the frame, but when I saw how relieved Alex was, I raised it up again. She hated this. She liked the "control" of knowing when she would be let down. I played this up and down game until she became more and more agitated at not knowing what I was going to do. Then, finally, I let her down.

Her shoulders were aching from the tension developed during the suspension. I ignored her discomfort, turned her around and attached her wrists to the top of the "X" frame. But this time I did not strap her body in place, instead I attached a stretcher bar to her ankles. Once again, I attached the hoist, not to the frame this time, but to the stretcher bar between her ankles. I slowly hoisted her body upward. Alex remained stiff, until she was parallel to the floor, hanging by her wrists and ankles, perfectly straight. It was a beautiful sight. The tension was apparent in her body. Her concentration was at it's peak. She had to focus on holding her body in this unnatural position.

I stepped between her legs and admired her dripping clit, breathing softly on it. I ran my hands over her body and watched her skin ripple. I rubbed my hands together to create electrical energy, and put my palm above her crotch

without touching her, and instantly she moved her pelvis to meet my hand. I motioned to Diana and had her stand between Alex's legs, keeping her mouth close to Alex's crotch, without touching it. I wanted Alex to feel her breath, and with each breath Alex trembled. This is exactly where I wanted her. In complete suspension, and in a time-warp where nothing else exists except what I am doing, and her needs.

When she began to lose her ability to maintain the tension, I let her down. She began to cum immediately. All the tension she had created to remain in position had become sexual energy. When she was released that tension had to go someplace, so it went directly to her clit, and nothing anyone could do would stop the reaction. The climax! When she was able to release her hold on me and stand up, I led her to the horse and placed her over it lengthwise. I began by putting a strap around her waist, cinching her to the horse. I continued by attaching her knees to the sides of the horse, keeping her legs apart, and securing her hands in front, out of the way so she couldn't interfere with me and what I was about to do.

The bardex was lubricated and ready for insertion into her defenseless bottom. She started shaking her head "no" when she noticed what I had picked up. When I touched her she found her voice and pleaded, "please don't." I knew I could have done anything else to her and not elicited this reaction. This was the first time I would share this incredibly intimate action with an audience. And even though she had told them about it, her vulnerability during the act was more than she could bear to show them. I ignored her pleas and inserted my finger up her rectum to relax her. Instead she stiffened her body and tightened her ass more. I continued the invasion until she was unable to

resist me any longer, then inserted the bardex nozzle. As soon as the first bulb was inside her I inflated it, doing the same to the second one outside her. She was gasping now, her body beginning to betray her. At this point there was no way for her to ignore her body or my intrusion, no matter how determined her resolve. I left her to endure the turmoil which was developing inside her. Her sex was stimulated at the assault, her mind was vanquished. She was confused and hated herself for her body's betrayal.

She could hear the enema container being filled in the bathroom, and knew what would happen next. While I was hanging the water filled enema bag, she became more animated, trying to dissuade me from continuing even though she knew in her heart there was no stopping me now. From experience, she could anticipate the sensations she would experience when the water filled her bowels. She began to feel those sensations before I even attached the hose to the bardex.

Alex resolved not to react. But she reacted. How could she help it? No matter how determined, how earnest she was in her desire to be stoic, to be composed, removed even; no matter how firmly she wished not to respond to the torrent of warm water which filled her, *she failed*. She could feel me entering her body in the form of liquid. I was now dominating her from the inside as well as the outside. She was being consumed with a desire, a craving for me to permeate her entire body. Oh, how the invasion filled me with lust. I wanted to ram myself inside her. To fill her other empty orifice as well. How I longed to have a cock to fuck her so I could literally feel her wet cunt spasm.

I released the belt which held her tightly to the horse to allow her body to expand with the water. When the enema bag was empty I removed it, but kept the bardex in place.

I pushed up against her bottom, bumping her in a fucking motion. I ran my hands over her trembling body, enjoying my invasion before lifting her off the horse. When she raised up, I put my hand on her stomach, admiring the swelling. She looked down at herself and gasped at the distention of her belly. She was impregnated with me. And now a new battle was underway within her. Her body wanted to expel the liquid, her sex wanted to keep "me" inside. She couldn't control herself or her emotions. Alex was a mass of confusion and raw sexuality, and I delighted in this Mastery, in this control, in this domination.

I began to deflate the balloon inside her only to reinflate it. I wanted to keep these sensations going a little longer. I wanted her to feel the pressure, the urgency within her loins to evacuate before I removed the bulb from her. I continued my game, and when I finally removed the bulb she turned around, grabbed and held on to me, shuttering for moments in orgasm. Eventually she was forced to carefully make her way into the bathroom to expel "me."

Would I fill her again? The second time would be even more devastating than the first. Hmmm?

I readied my equipment for the next step. I would wrap her with plastic wrap, and then I had a little surprise in mind. She was waiting at the bathroom door, waiting to see if I were finished? Waiting for the next step? Maybe just trying to orient herself. Well, I was ready for her. I brought her across the room to my bondage table, stood her against it, and began by wrapping each arm and leg with the plastic, and eventually continued to encase her entire body. Together the three of us lifted her onto the bondage table. I made sure every inch of her body from her neck down was well wrapped. Then I finished the process by taking new rolls of plastic wrap, and wrapping Alex and the table

together, wrapping her *to the table*. Now she was unable even to wiggle her arms or bend her legs. It was successful. She was shaking her head "no" while I slowly completed my task. I smiled. I was enjoying this. The sexual energy was swelling up inside me, arousing, stimulating, and spurring me on to more sadistic activities.

I slowly and deliberately rubbed my hands all over her body, making sure all pieces of the plastic were stuck together, also using this action to make her squirm. Her body was so sensitive that each touch, however slight, would cause her to writhe. I pressed hard on her pelvic bone and could feel the spasms within her. As long as I held pressure on her body the spasm continued. I wanted her to feel as though she were being pinned to the table like a specimen in an experiment. I picked up a 35-pound weight and carefully placed it on top of her crotch, slowly allowing the weight to pin her. She gasped. I studied her reactions. I wanted to get inside her body. She didn't disappoint me. Her reactions were gratifying. She was unable to move anything except her toes, and they were in constant motion. Her eyes would roll back into her head, then they would focus again on me. I stood over her head watching each movement of her face. I watched her eyes and mouth as well as her toes. The story was unfolding. The swell of her arousal would peak then subside, only to reactivate again even more rapidly.

Eventually I removed the weight but continued to caress her body. My hands examining each part of her plastic-covered body. Finally, my hands stopped at her crotch. I plunged my knife into the gap between her legs, stopping short of touching her. I cut a hole and placed a vibrating ball about the size of a jaw breaker between her engorged and protruding lips, right on top of her clit, and then

resealed the hole. She stiffened and shuttered. Once again she was forced to focus her attention on her sex. I put my hand on top of her crotch. I could feel the vibrations radiating throughout her loins. The sounds she made were animal-like. She was unaware of the gag I held over her mouth, so I pinched her cheeks until she opened her mouth and I was able to push the gag inside. I strapped the gag around her head, also connecting it to a strap that ran under the table, making it impossible for her to lift or turn her head. She hated this further immobilization. I invited the women to caress her as a way to further enhance her sexual vulnerability. While they were busy playing with my toy, I prepared for my next activity.

I connected a bottle of water to the beam above my victim. To the water bottle I attached a short hose with a "raindrop" fitting on the end. Her eyes widened as she realized what was going to happen next. She had experienced this torture once before, and hated it. It would soon consume her entire being.

I cut the plastic wrap again, removed the ball and peeled the plastic completely off her crotch. She watched intently as I raised my hand to release the fluid to drip onto her naked clit. I moved the table a bit so the drops of water were hitting the exposed, now engorged clit head directly. I then adjusted the water to drip about every second. Alex attempted to shake her head "no." Bodily movement was minimal, but I saw it. However, her toes were still in constant motion.

There was no actual visual reaction to begin with. However, forty minutes later she was writhing in painful agony. Each drop vibrated through her body. She would moan between drops, and a cry would escape when each drop hit. She was soon begging to be released, muffled

though her words were, I could understand them. Her supplications fell on deaf ears. I watched the pulsing blood flow through the artery in her neck, and was surprised to see it was beating in time with the drops of water. I knew the throbbing of her clit would soon join into the chorus. She had endured hours of sexual torture at this point, and no longer had any control of her body, mind, breath, clit or heartbeat. Now it was time for me to sit back and watch while she suffered the current torture.

We three sipped our wine and ate caviar as we watched the waves of sexual arousal course through Alex's body. What, at another time, would have been sexual pleasure, was now sexual agony. We talked together just loud enough for her to hear that we were speaking, but not loud enough for her to hear what we were saying or to disturb her mind-set. I wanted to enhance the bizarreness of this situation. We could see her trying to grasp reality long enough to convince herself that this was only a fantasy and would end shortly. However, her judgment had been impaired by the intensity of the day's activities. Her momentary grasp of reality would fade, and she could not concentrate on the span of time that had elapsed. Minutes would seem like hours, and one hour like several. This confusion about passing time would make its own—in my view *welcome*—contribution to her condition.

I could see that her breathing, the pulses of her blood, and the throbbing of her clit were beating as one, and I knew the desired effect had been achieved. Her body was cooperating with me by creating a sexual animal with only one need: to be satisfied. Her body was hungry for me, her tongue was growing hard like her clit. As I removed the gag, her tongue became erect and protruded. She had difficulty containing the organ and, when I released it, it

became alive with a need of its own. I stroked her body in various places with my finger, and my touch was transposed, experienced as though I were stroking her clit. It didn't matter where I touched her, she became stimulated to orgasm.

When I removed the drip she screamed. It was not a woman's scream, but the sound of a wounded animal. Her body convulsed for minutes before the effect lessened and she was able to calm down.

Leaving her attached to the table, I mounted her. Her body craved my weight, my attention. I sat straddling her, sex to sex, separated only by the plastic wrap. I could feel her lust surging through my body. Her struggles became more violent, her body was contorting within the wrap, convulsing, trying to reach me. I laid full length on her, my body covering hers, my mouth sucking in her tongue, feeding the fires within her even further. At that moment I knew she would do *anything* to reach me, hold me, crush me to her. The wrap that separated us was like steel bands keeping us apart—immobilizing her.

Regretfully, I dismounted. It was time to release her from this prison of torment. She had endured this paralyzed state long enough. I began to slowly unwrap her. As I peeled the plastic from her skin, the air caressed her and she began to shudder. I held her firmly in my arms until the convulsion diminished, then continued the action of releasing her. As soon as her arms were free she grabbed me around my neck, pulling me down on top of her, holding on as tightly as she could. Her arms were trembling, but the sexual energy was as strong within her as I had ever felt it, and she used it to capture me. I responded. It was thrilling.

Her body was free of all restrictions, but her mind was

still imprisoned. She lay there trying to move, but unable. I could feel the life creeping back inside her, and turned her over on her stomach. I rubbed her bottom, preparing to spank her. She began thrusting her ass in the air, inviting me, and I responded with the flat of my hand, delivering a crashing blow to her luscious bottom. She sucked in her breath and held it as long as I pressed my hand heavily into her bottom. Her body began to undulate with her climax. I spanked her again, each blow as hard as I was capable of delivering, pressing into her bottom with my hand after each blow. Then I began to pick up the pace, spanking her slowly but rhythmically to begin with, then stopping, holding my hand in place, allowing her to catch up with me—and climax. I continued spanking her faster and harder until my breath was labored and my climax complete.

It was over. Finished. She had been taken. Guests forgotten, we held each other, slowly coming back to reality. It took time to come back from that place we had both gone together.

THE PORN PATROL

November 1991

It was late. I was in bed watching the news when the phone rang. "We're holding your husband hostage. What will you give us for his return?"

My husband? He was out "taking a walk," which—translated from his language to reality—meant he was in a bookstore, and was oblivious to the time. The only thing that alerts him to how long he's been there is that his feet start to hurt.

"Keep him!"

"What? Just a minute. . . ." I heard fumbling on the other end of the phone. Some hushed conversation and laughter. It was Alex and a couple of her girl friends. "What do you mean, keep him. He was in the bookstore, and we kidnaped him."

"I figured he was there." They had been cruising around, and decided to go to Alex's favorite bookstore which is open all night, and has an extensive porn section with good S/M magazines. They saw him standing there, and surrounded him demanding his wallet and keys, and for him to come with them. Can you imagine, three beautiful young women dragging this *hardly-protesting* man out of a porn bookstore? A couple of men standing there, reading, had offered themselves in his stead. But they rejected the

163

volunteers with, "Sorry, only one per night."

"We're bringing him home to you. We don't want him." The phone banged down.

I knew it wouldn't take them long to get here, so I put on my velvet robe, picked up my cane and went into the living room to wait. I opened the drapes of my picture window just a bit to allow me to see when they arrived. I wanted the visual to be perfect.

They asked him where his car was, and he told them. One of the women decided to drive his car home. Alex wrapped her scarf around his eyes, and the three of them walked him to her car. They put him in the back seat, and the other woman sat in the back with him to make sure he didn't remove the scarf. They were spinning a story of taking him back to their place to use him, beat him, and keep him prisoner, since I didn't want him. Alex drove, starting a direct route until my husband decided to play his own little game with them. When they would pass a certain intersection, he told them where they were. They would hit a bump, and he would once again tell them where they were. He was keeping track, so Alex started taking back roads and going around blocks to confuse him, which was difficult to do.

They arrived. When I saw the car pull up, I put on the inside lights so I could be seen well, opened the drapes completely, and stood in the window, cane in my right hand, tapping my left palm with it. I was a picture of dominance. The three of them were walking him up the drive, walking around imaginary obstacles still maintaining that he was going into Alex's house. When they got to our front porch, they pushed him through the front door. Then, while bumping into each other, they tried to make a swift retreat, lest the cane be used on them. One of them

reopened the door and threw in his keys and wallet, before running to join the others.

When he unwrapped his head, he knew where he was, but then he saw the cane. "Have a good time, Darling?"

"Well, it was quite an experience," he said, with just a little nervous laughter.

"You were awfully late tonight. At the bookstore again?"

"Ah, yes, I was. I didn't realize how late it was getting." His nervousness was mounting.

"Well, tonight I'm going to remind you that I'm not so happy waiting at home, wondering where you are, and when you'll return. So I think six-of-the-best will be a good reminder. Don't you?"

"You really don't have to do that. I'll remember."

"No! I really do have to do that. You don't remember. That's the problem. So I think you'd better drop your pants and bend over the game table."

I closed the drapes, locked the front door, and returned to find him in position. "It's been quite a while since I've had to do this, but you won't forget tonight for a few days. Raise your bottom. I'm ready."

Yes, he will stay out late at the bookstore again, and yes, I will cane him again. But, oh, does it have its rewards.

FORTY: A Rite of Passage

March 21, 1992

Written by Britt

Prologue

The rain had stopped, a good omen. City lights reflected off of scudding clouds on the horizon. Overhead the sky was clearing, revealing unusually bright stars due to the rain washed air.

By 7:30 parking near 6111 was at a premium for at least three blocks. A limited number of privileged guest witnesses, all in dark clothing, slipped through the atmospheric night into the house and into an adjoining theater. This was to be an evening of rare theater and high drama. And it was to begin at 8:00 p.m. sharp!

The theater was dark except for banks of large votive candles arranged in a circle around the center of the stage/sanctuary. Three subdued spotlights further illuminated the center of the circle, revealing a host of shadowy figures in brown or blue coweled monks robes—the priests and acolytes for the ritual—for this was also to be an experience in spirituality unrelated to any tradition except its own.

The waiting circle of coweled figures shifted silently in

anticipation as the appointed hour neared. A break in the circle would remain open until the Initiate was brought in. Music of liturgical appropriateness swelled in intensity.

A further prelude to the ceremony was taking place at rear center-stage as one of the group's skillful Masters sensually reddened the back of his boy with two impressive whips. The young man's body pulsed with each blow. He strained gratefully toward the welcome strokes from his position on the large St. Andrew's Cross.

At the last moment, a commanding silhouette in white slipped into a chair at the foot of the sanctuary, facing the center. All knew that this presence was Mistress Nan, the loving authority over Alex who was to be the focus of this special celebration of her fortieth birthday.

The ritual was about to begin.

- I -

Carefully selected Gregorian chants played, and the space seemed charged with electricity as Alex was brought in, controlled by robed Restrainers. Dressed in a tailored black skirt and jacket, the beautiful woman's knees were already buckling in fear as she tried to pull back from the circle to which she was being led, soft moaning sounds already escaping from her lips.

The circle of hooded figures closed in around her, blocking any avenue of escape. While Alex was still being held for security and support, hands appeared from the long sleeves of the mysteriously robed participants, forcefully pushing and shoving at her. Two robed figures moved in to remove her skirt, the first act of the ritual, the gradual stripping of her body.

A hissing chant came forth from the anonymous coven as

they continued to press in on her: Alex, Alex, Allleeeexxxx. Hearing her name intoned over and over, Alex appeared on the verge of collapse, her fears were, by now, almost beyond control. Yet the ceremony had hardly begun.

While Alex was being forced to the center of the circle, the whipping scene was ending at the rear wall. The cross was now bare except for the attached shackles, its monumental hardness beckoning to the nervous woman. Would she be next? But Mistress Nan had other mental as well as physical tortures planned for the trembling Miss Alex! She had always found fear stimulating as well as terrifying. Tonight she would be pushed to the far edges of terror.

An impaler bench was silently brought into the center of the circle. Alex was lifted by her Restrainers onto the bench with her legs spread to either side. The padded bench was not yet equipped with any impaling device, but it was fitted with cuffs and chains for ankles and wrists. Two Dressers came forward to gently remove her jacket, heightening her nervousness over eventually being naked before all.

Beneath the jacket, Alex was sensuously attired in a figure revealing black lace corset and panties, exciting attire for such an exciting woman. The corset framed and accentuated her now heaving breasts, her compact torso and narrow waist. No wonder she was often referred to as "the lovely Miss Alex"!

Anonymous hands now slipped her ankles into the cuffs and adjusted the chains to just the right tension for holding her upright on the bench. Her wrists were then cuffed behind her back, and the chain was stretched to an attaching point at the back of the padded seat. The attendants withdrew, leaving her in this physically and psychologically vulnerable position. Alex's submission deepened.

169

Hung from the high ceiling near the inside edges of the circle were six long steel chains with a large ring at the end of each. These were to provide support for the six submissives who now came forward. Each of them grasped one of the overhead rings with both hands. No shackles were necessary as the powerful minds of the four Whip Masters standing next to them were enough to hold them in complete captive surrender.

The submissives, with bowed heads, were each to receive forty lashes as surrogates for the quavering woman. But Alex could hardly know that she would ultimately be spared the actual physical lashes at this time. Spared the lashes, but not the mental stress! The spectacle surrounding her was to increase her apprehension as well as spare her energy for more intense rituals to come.

As the Whip Masters lashed into the backs of their submissives the hooded figures began to chant: "One . . . two . . . three . . . four . . . ," in measured cadence, louder and louder, "five . . . six . . . seven" Alex quivered and moaned. She felt the electricity of each blow as intensely as if her own flesh were being stressed and caressed by the whips. Her mind reeled. Minutes passed. The musical chanting kept time with the lashes as they quickened.

The counting increased in intensity. Alex's moans became more audible, her vicarious experience of the blows sending body-wracking shudders through her. "Thirty-five . . . thirty-six . . . thirty-seven . . . thirty-eight . . . thirty-nine . . . *forty*!" Alex started to swoon as the last blows were delivered. Her restraints held her securely on the bench, but no more securely than the eyes of her Mistress who sat silently opposite her. No matter what happened, no matter what was in store for her this night,

Alex knew that she must endure, would endure all for her beloved Nan.

Her attendants came forward and released her from her chains. Her shoes were temporarily removed while her stockings were being stripped away. The shoes were immediately replaced. Skillful hands quickly unlaced her corset and removed it. The panties remained. Her smooth, perfectly proportioned body was now almost naked before all. Admiration and awe could be felt for the beautiful, surrendered lover of Mistress Nan.

A temple gong sounded.

- II -

Alex was lifted from the bench. Hooded figures removed the impaler and swiftly positioned an altar into the spotlit center. Alex stiffened momentarily as she was lifted onto the altar on her back, her head at the far end. Her swollen mound was now directly in front of Nan and illuminated for all to admire.

Shackles attached to the four corners of the altar secured her wrists and ankles. Alex's chest heaved, her legs shook. It was clear that she was hyperventilating and was challenged to control her body.

A figure in a starched white nurse's uniform appeared from the circle and took her place near the head of the altar. Nothing was left to chance in the ritual about to be performed on Alex's smooth bare flesh. Although in an agitated state, Alex recognized the woman, Susan, a friend from New York who was her equal in the mental games she loved to play! Susan's presence was hardly reassuring!

The seated, white-robed figure now rose and calmly strode to Alex's head. From the long white sleeves of her

vestments, Mistress Nan's hands emerged and began to seductively stroke Alex's hair, cheeks and breasts. Alex's restrained legs twitched as Nan's touch continued down her body, feeding her apprehension. Nan stretched forward and placed her right hand over the woman's pulsing clit, already wet beneath her panties. After a few moments, Nan declared: "She's ready."

Three men, their supple physiques stripped down to leather jock straps and boots, moved into position at Alex's left side. It was The Fire Master and his slave assistants. One slave carried a tray on which the implements for the ritual rested, the other held a towel.

Mistress Nan, having returned to her seat opposite Alex, calmly intoned: "B!" Taking a small amount of mysterious liquid on a sizeable swab from the container before him, the Fire Master reverently traced the letter "B" on Alex's abdomen. Alex moaned, still not sure of what was about to happen. The Fire Master struck a match in his left hand, holding it for her to see, increasing her terror before deftly touching the fire to the anointed area. The restrained woman moaned again and her legs stiffened as a blue flame "B" licked quickly across her flat stomach. Just as quickly, the Fire Master's right hand brushed across the flame, extinguishing it almost immediately.

"F," Nan directed. What fears pulsed through Alex's mind as the ritual was repeated over and over with the initials of several of her closest friends? Would the warm sensations of the rapidly extinguished flames increase to burns? Would she be marked? One after another Nan continued: "S," "M," "D," "H," "J." Alex moaned each time the blue flames flickered across her in a fiery burst. But if this was what her Mistress required of her, she would endure despite her fears.

172

And at last, "N, for Nan, closest to the heart." It was the Firemaster who spoke this letter. Then he moved from Alex's abdomen to a spot below her left breast, traced the sacred letter, and holding the match for a moment before her eyes, touched it to her flesh. The blue flame, fueled by Alex's love for Nan, appeared to burn brighter and longer before it too was extinguished.

"Nan, I love you!" Did Alex actually speak the words, or was her emotion so focused that all present heard it in their own hearts? Time suspended in the silence that followed.

At last the Firemaster replaced the ritual swab on the tray and withdrew into the darkness with his submissives.

The gong sounded.

- III -

Hands trained many times to the task quickly released Alex's trembling limbs from the shackles. She was carefully brought to a standing position as the altar was whisked away into the darkness. The attendants removed her one remaining protection, her panties, Alex was now stripped naked, physically and emotionally, before all her friends. The spotlights taunted her unmercifully. She felt completely vulnerable!

Knees buckling, Alex appeared to have little strength left, although her rite of passage was not even half completed. She indeed needed the support of her Restrainers, who held her in a standing, spread-eagle position, her arms pulled out tightly on either side. As fragile as she now felt, she would have to draw upon an extraordinary reserve of endurance in order to continue.

A tall, commanding man strode into the circle opposite

173

her. A supple black leather cape, clasped by a heavy steel chain, covered his body. To his left and slightly behind him followed his slave with a tray. With great drama, the Master Unctionary swirled off his cape, revealing a physique attired only in boots and leather cod piece. Alex stared at him like a deer caught in headlights!

At a signal from his Master, the slave knelt and offered the tray. The Master reached for a bottle of oil equipped with a hand pump. As though he were a marksman shooting a gun, the Master shot the sensuous liquid onto Alex's pulsing body. Again and again the oil struck her, anointing the front of her completely. The oil slithered down her swelling breasts, trickled over her erect nipples and flowed onto her heaving abdomen. Alex's torso glistened outwardly and tingled inwardly with delicious erotic sensations.

A well-aimed final shot struck her directly over her excited slit. Alex shuddered as the viscous liquid embraced her sweet lips and worked its way into her highly charged clit. It was as if tiny, ghostly fingers were caressing and invading her. Low moans continued to escape uncontrollably from her throat. The Master Unctionary replaced the oil on the tray, then moved toward her in a slow, fluid motion. Kneeling before her, his mesmerizing gaze never left her eyes as his hands began to caress her flesh. His were not ghostly fingers, but powerful and supple ones, which began a slow erotic dance over her body. The Master's palms and finger tips flowed firmly over and under her protruding breasts, up to her arm pits and out along her extended arms. It was not a mere spreading of the oil, but a ritual massage that manipulated her mind and soul.

Powerful waves of control and surrender washed back

and forth between Alex and The Master as his hands continued to whisper dark secrets over her body. In her altered state, Alex moaned almost constantly. Though not painful, the intensity of the oiling was almost too much for her to bear. Her nerve endings fused.

The Master Unctionary finally stood and walked, with hypnotic control, backwards away from Alex. His slave was kneeling, waiting with the leather cape, just to the left of the point where the Master stopped. Taking the cape in both hands, the Master swung it dramatically up, over his head, and began to swirl it in a circular motion in front of Alex. The black leather fanned her anointed body with a flood of cooling sensations. At last he swung the leather over his shoulders and fastened the chain clasp. Suddenly Alex's eyes widened in amazement as the Master, with a "fuck you" gleam in his eyes, unexpectedly flicked his right thumb off of his upper front teeth at her! Her mind twisted.

With panther-like hypnotic grace, the Master Unctionary and his slave turned and quickly melted into the darkness.

The gong sounded.

- IV -

Again, the altar was brought into position, and again Alex was lifted on to it as before. Again, her limbs were restrained by the shackles. And again, she shuddered and moaned with sexual excitement and apprehension.

The large votive candles which had demarcated the circle when the ritual began were now in the hands of the surrounding acolytes. They had been burning since before Alex was brought into the sanctuary, and they were loaded with hot wax!

Alex closed her eyes as she perceived what her fate was

to be. Her mischievous ways had taunted just about every member of the circle. Everyone desired Alex, but only Nan could have her. They were about to have their loving revenge! She was justified to be afraid to see which faces were hidden within the cowels. The first hooded figure moved solemnly to Alex's side and, holding the large glowing red glass jar above her, slowly poured the hot liquid onto Alex's heaving chest. Deep sounds came from the center of her being as she writhed under the wax's sudden burning impact. Alex experienced sensations that were far more intense than those of the earlier ritual by fire!

Nan, now at a position near Alex's head, whispered into her ear to further torment her. The next figure came forward and emptied a glowing oblation onto another patch of her traumatized skin. One by one the entire assembly came forward. Soon Alex's breasts were encased in the coagulating wax, which was—as each successive layer cooled—only a bit easier to endure. But as each acolyte found a new bare area for the hot, kissing liquid to baste, Alex groaned almost continuously. Slowly they coated her flesh in successive arcs, now nearing her pulsing, wet labia which were not to be spared. Alex's terror and excitement were at fever pitch as the sacred opening, the doorway to the mystery of her womanhood, was sealed.

The candles, many of which had been extinguished by the flowing wax, were withdrawn, empty. Nan returned to her throne.

The gong sounded.

- V -

Still breathing hard from the rapid overflow of sensations she had been pressed to process, Alex lay still for a few

176

moments, struggling to prepare herself for whatever was to come next. And that which was to come next would just about blow out all her circuits! Her Mistress' ceremony was bringing her close to the edge of total terror. But Nan, after nine years with Alex, knew every crevice of her mind and would hardly let her beloved fall into the abyss.

Into the circle strode a stunning black woman. Soft, urgent intakes of breath could be heard. A full head of raven hair framed her beautiful, high-cheekboned face. Indeed, she brought to mind a mesmerizing bird of prey. A shining black rubber corset proudly lifted her magnificent breasts, while accenting her narrow waist and sensuous hips. Stiletto heels augmented her already commanding stature. She was the revered and feared Mistress M who had a reputation as a loving, playful sadist. Imported from New York to bring Alex's terror close to climax, she was about to fulfill her mission!

Mistress M seemed to float slowly to Alex's left side. "Slave!" she commanded, in a voice that propelled into motion her male submissive who had been waiting at the edge of the circle. "Here!" The chain-harnessed man jangled softly as he moved to her side. Like the Mistress of an animal with a bell, M knew where her slave was at every moment.

M was already hovering over Alex, penetrating her with her hypnotic eyes. Kneeling, the slave offered up a tray. His Mistress turned to select a long, pointed dagger. Holding the dagger menacingly over Alex, M displayed the blade to her panicked target. How much more could Alex take before turning into a mindless mass of quivering protoplasm? She was about to find out as the Trial by Knives began.

As M brought the knife down to Alex's chest, she spoke

177

to her sacrificial victim in mellifluous, soothing tones. Alex had no option but to surrender as the sharp side of the blade was drawn teasingly over her wax-encased breasts, quivering torso and pulsing slit. The knife worked its way sensuously back to her breasts, and penetrating the many layers, began to skin away the wax in large sheets.

M's blade moved with increasing speed and deftness as it freed Alex from her wax encasement. Was she being nicked or cut as the blade reached her loins? She feared that it was so!

At last Mistress M returned her instrument to the tray only to select a more dangerous, sharply pointed serpentine dagger. She also selected a long tapered sharpening stone, and holding both over the traumatized woman, began to whet the curved edges of the knife. The blade screeched and protested against the stone as M honed the dagger to an even greater sharpness!

In tones that completely paralyzed Alex, the Mistress of Knives hissed, "Don't move! I'm going to carve Nan's name on your belly!" Frozen with fear, Alex lay still, her abdomen exposed to M's demands. Her state of surrender was complete as she lifted her belly to greet the tip of the blade. At that moment she welcomed the marks—for Nan.

M handled the curving knife with consummate grace and control as she traced the first letter on the naked flesh: "N," she intoned, "A, we're halfway there . . . N!"

Was she cut? Had Nan really had her marked at last? Moaning softly, Alex's mind reeled in a transfigured state of complete surrender.

Mistress M's slave slipped into the shadows as the Mistress was invited to sit down at Nan's right in the position of honor.

The gong sounded.

- IV -

A beautiful submissive came forward and bowed before Nan. Mistress Nan rose from her chair, her white satin robe and black jacket falling behind her. Like a divine Mother Goddess with flowing red hair, Nan walked to the left side of the circle. She was wearing a black silk bustier, a corset-like garment which displayed her ample bosom and defined her waist. A flowing black skirt and black high heels completed her attire. A large nine tailed whip hung languorously from her right hand.

As she turned to face Alex, a flash of silver gleamed from her throat. It was a stunning silver whip necklace which curved over her bust and around the back of her neck. The long braided silver tails of the "whiplace" then flowed down under a silver handle and cascaded over her right breast, the tips swinging gently with her movement. It presaged the ritual which was about to begin.

Facing Alex at the foot of the altar was a girl in a cape. By the time anyone noticed her, attendants were approaching to tear away the cape. She stiffened her limbs as the four assistants lifted her, floating her up over Alex. Gently, they positioned her directly on top of Alex, breath to breath, breasts to breasts, and pussy to pussy. Immediately, she started fucking motions as her full weight pressed into Alex. A muffled moan escaped from the crushed woman's throat. The shackles which held Alex to the altar were removed and attached to the Girl's wrists and ankles. Alex was pinned down by the humping surrogate.

The girl was dressed in the ritual vestments of her station: black stiletto-heeled pumps and a torso hugging black corset. The corset was cut high over the hips, exposing the firm oval melons of her buttocks. The spotlight

179

gleamed on her beautiful, smooth ass. It was a perfect target for Nan's flogger, which the Mistress had begun to swing hypnotically at her right side in increasing arcs.

Thud! Nan delivered a perfectly placed first stroke to the surrogate's bottom. Whack. Crack. Crack! The girl continued pumping Alex, but the rest of her body remained motionless as her ass greeted each blow with hunger. The vibrations flooding through her body were transmitted—without any interference—into the heaving woman beneath her. Alex would experience every blow as intensely as if her own bottom were receiving the whip's kisses.

Nan was masterfully swinging the flogger from over her head now, the tails of the silver whiplace moving in harmony with her motions. The blows were coming faster and harder as she moved from left cheek to right cheek, back and forth, harder, harder, harder! Nan moved to Alex's head, and without missing a stroke, crooned several times: "You can feel it, can't you! This is for you. Feel it! This is for you."

From beneath her surrogate, Alex managed to communicate total acceptance to Nan as she panted and moaned with each stroke. Nan circled the altar and continued her severe lashing of the girl's reddened, pumping backside, whipping her as she would have whipped Alex—as a gift of love.

As the intensity of Nan's blows increased, soul invading music swelled in complete accord. Did the crescendo of sound spur Nan to new heights of passion, or did Nan push the music onward with that passion? As the whipping and the music reached a simultaneous climax, suddenly the whip itself seemed to recognize the perfectness of the moment. As the whip swung down by Nan's side for the last time,

it slipped symbolically from her grasp. Nan walked away waving a dismissing gesture: "It's enough."

Nan returned to her seat. The assistants immediately came forward to release the Girl from Alex's straining body. Not only did Alex experience each and every stroke of the heavy whip tails, the ritual had also been an exercise in breath control. Alex gratefully sucked air into her heaving lungs.

The girl was placed at Mistress M's feet, her head to the floor.

Alex was gently lifted off of the altar. The air seemed liquid as she was brought to a standing position and held immobile by her Restrainers. For a moment Alex thought her ordeal was over. Her entire body reached out in desire to come to Nan, but Nan merely smiled at her as she was propelled backwards. It then dawned on Alex that she would have to call upon a hidden reserve of strength to continue. Slowly Alex opened her doe-like eyes and caressed Nan with her gaze. Her lips moved to silently form the truth, "I love you."

The gong sounded.

- VII -

Was there more to endure? She should have been close to being broken! However, her terror had produced a surplus of adrenalin, which in turn created an incredible state of excitement. This high, which flooded Alex's body, mind and soul, sustained her. But the final, and most terrifying test of her delicious surrender was about to be played out.

The altar had been whisked away, and the impaler bench brought back into place behind her. This time the impaler

was equipped with a sizeable dildo. At first Alex was not aware of it, but it was soon to make its presence impossible to ignore! Many hands supported her as she was lifted high over the bench and held upright over the dildo, her legs spread to either side. Slowly she was lowered onto the erect phallus. As the hard cock slid into her moist, excited vagina, an intense, low groan welled up from inside her. The bench forced her legs apart further. Attendants kept firm grips on her arms and upright torso as her head pitched forward.

Mistress Nan walked solemnly to Alex, removed her gold earrings, then moved to the back of the impaler and stood behind the trembling girl, supporting her. As Nan pulled back Alex's head by firmly grasping her hair, more sounds escaped from her partially opened mouth. By Nan's action of removing the earrings and exposing her ears, Alex began to fear the worst—*needles*!

Alex had never been pierced. She was absolutely terrorized by the thought, and for many years had managed to escape that ordeal. The Master Piercer, came forward with her two assistants. The nurse bore a large tray of the instruments of the Piercer's profession. Alex knew that her time had come. She knew all too clearly that this was not to be just a mind fuck. This was the real thing!

Her tortured mind raced like the wind as the hooded figures, of whom she had lost all awareness, began to chant, "Alex, Alex, Alex" Her terror was now complete. The space around her whirled and distorted as in a time warp.

The Piercer moved to her left side. As she approached, Alex managed to utter one sustained moaning word, "Nnnnnoooooo!" But, her eyes closed. The swirling, half-dream state did not cease.

182

Alex felt gentle fingers on her left ear lobe. Any pulling away from the touch was prevented by Nan's firm grip on her hair with one hand, while the other hand cupped her chin. Nan pressed her thumb between Alex's teeth, giving the trembling woman a lightening rod for her fear. The Master Piercer then made a small dot with the fine point marker she held in her right hand.

Alex's terror was real! Needles!

Alex moaned audibly as a piercing hemostat was clamped onto her left ear, the black dot positioned in the opening. Her breathing all but stopped, and her eyes remained shut! She endured the full weight of the clamping device hanging from her lobe as the Piercer turned to pick up the sharp, sizeable piercing needle. The surrounding assembly took a deep breath and seemed to draw back in unison. With one hand on the clamp, the Master brought the needle to its mark, and pushed.

"Uuuuuuuuhhhhhhhhhhhhhhhaaaaaaaaahhhhhhhhhhhhhh..."

Catharsis! From the core of her body and soul came the sound that only the first time piercing of flesh produces. At last her greatest terror had marked her soul forever. A gold earring in the shape of a free form "X" was inserted into the new opening in her flesh.

Alex would have collapsed had she not been held upright on the impaling dildo by Nan. Electrical waves seemed to pulse back and forth from the hard, moist phallus to the ring in her tingling flesh. It was a moment suspended in time that she would never forget. Her emotions swirled. Born in the lightening crack which had penetrated her soul as sharply as the needle, was a vast nebula of love for Nan.

Nan continued to hold Alex's head motionless as the Master moved to her right side. It was to be *both ears*! The procedure was then repeated. She now had a golden "kiss"

on each ear. Adrenalin raced through her being. More animal-like sounds surged forth from her· parted lips. Torment now melded with loving ecstasy.

Alex had thought it impossible to feel more love for her Mistress. She now realized, in a blinding flash, that she had been wrong!

Her rite of passage was accomplished.

The gong was silent.

Epilogue

The air seemed charged with the beating of unseen wings. No one moved. Time remained suspended until the assembly, also in need of release, finally broke into spontaneous applause! An off-key chorus of "Happy Birthday" helped to further dispel the tension which threatened to overwhelm everyone present.

Mistress Nan cradled her beloved in her arms. Alex's head slumped, her complete surrender beautiful beyond words. Softly, from the core of her being, Alex managed three words to Nan: "I love you."

Silence.

Then Nan spoke, "Alex can't speak right now, but we want to thank each and every one of you who participated in or witnessed this celebration of Alex's birthday. Those of you who would like to stay and play are most welcome to do so. And please feel free to go into the house and begin the party. We'll be along shortly."

Alex was gently lifted off of the impaler, and Nan's black jacket was slipped around her shoulders. With their hoods now thrown back, familiar friends continued to surround her with congratulations. After a few moments, Nan fended them off to give Alex a much needed breather.

The participants removed their robes and slowly filtered into the adjacent party rooms to find a sumptuous spread of salads, paté, chicken and other goodies. A long side table featured various other foods and condiments, in the center of which lay a beautiful girl clothed in fruits and vegetables, a living cornucopia. Next to it was another table with a birthday cake and other fattening desserts! Thirsty throats soon found the open bar on the enclosed patio.

In the living room, several well-wishers milled about, waiting for Alex to be seated in a high-backed chair. She wore her stiletto heels, her dignity and Nan's open jacket which revealed her glowing body. In spite of her incredible state of high, Alex had managed to find her voice at last. But words were not necessary as her shining eyes clearly revealed her transfigured soul.

Nan sat to Alex's right. The man who had served as the Master Unctionary came forward with a silver tray. On it was an object loosely draped in black cloth. With the same panther-like grace he had displayed earlier, the beautiful man carefully folded back the cloth. A gleaming crystal box appeared, its edges seamed with silver beading. On a roundel of glass in the center of the lid was a frost-colored image of a whip, hand sandblasted into the glass from the underside. Crystals were dramatically mounted on one corner of the lid. The mirrored bottom of the box created a dimensional double reflection of the sweeping design. It was a magical creation. It's creator stood by with justifiable pride.

Alex seemed in awe of the beautiful box. At first, she was reluctant even to touch it, but soon her curious fingers found the lid as she examined it reverently. Alex was greatly moved by the man's special gift!

Another presentation was announced in resonant, stentor-

185

ian tones. The speaker expressed the circle's love and admiration for Alex, then he handed her a piece of graphic artwork which had been signed by all who had contributed to the gift he was about to present to her. Mysteriously, he announced that it would be six weeks before Alex could really enjoy her gift!

He presented a small black jewelry box, pulling back the lid as he extended his hand toward Alex. A pair of diamond earrings sparkled before her eyes! They were impressive, over 1.6 carats of flawlessly cut gems! Alex again lost her voice, but her moist, beaming eyes conveyed her love and gratitude to the group. And now she had the perfect place for them while her piercings healed thoroughly, her new crystal and silver box!

Guests and good friends now mingled freely. Vibrations which had been so electric earlier were only partially subdued. Everyone seemed to float on a group high.

Later in the evening, while several guests were off in the theater playing, and few remained in the party areas, Alex was, at last, alone with Nan. She whispered mischievously to her Mistress, "I didn't get my birthday spankings!" She was immediately pulled over Nan's knee on the couch. Forty whacks reddened Alex's bottom, and provided the only intimate lovemaking between the two long-time lovers that entire evening. A strongly and mutually desired emotional climax was accomplished at last.

The magical evening didn't want to end. And it wouldn't. Whether guests stayed to play longer or whether they slipped out into the star-bright night, they took with them an experience they would not forget: a true, never-ending story of devotion and love.

THE BRIDE & THE DEVIL

Halloween - 1992

Excitement was in the air. Anticipation had us all a little anxious. As we drove to the party, fantasies were running through my mind like movie clips, and they refused to stop. Just what would happen tonight?

We were comfortably seated in our Town Car, driven by The Chauffeur from Hell. Her passengers were Death, A Young Man From Prep School, The Devil's Bride, and, of course, The Devil. The Devil was dressed in a tuxedo and wore a top hat which conveniently hid her horns. The Bride was appropriately dressed in red. Everything she wore was red—panties, shoes, stockings and, of course, her dress, which was slit up the front for easy access at all times.

The Devil, the School Boy, and Death got out of the car when we arrived, and allowed the Bride to prepare herself as directed. She removed her panties, and was handed several items, one at a time, to slip on. These items were the colors of the night—red and black—and they completed her attire for the evening. She put the cuffs on, and placed the magnets on either side of her clit and labia lips as she had been previously instructed. When she was handed the collar there was an almost imperceptible hesitation while she grappled with a new understanding: she was literally entering a new degree of submission.

(After ten years of being Alex's dominant, I never tire of watching the dynamics of submission transform her. But tonight was different. Usually our scenes start with her arrogance, and end with her submission. Tonight she had given herself to me with no restrictions, no questions, and no expectations, and our scene would start with her submission.)

She presented herself to the Devil to be blindfolded and bound. Her elbows were tied to her sides to hold her straight, and her wrists were attached in front. A black rope was attached to her wrist cuffs. Then, with Death at her side, she walked into the affair.

The party was already underway. Costumed participants were socializing, playing, and observing. As the Devil led her blindfolded Bride through the crowd, which parted to allow their entrance. The Bride was jostled from every side. Eyes turned to view the spectacle that was slowly moving through the area. Some understood the scene immediately, others looked on with wonder and admiration, questioning its significance. The Bride was familiar to almost everyone there, but not as this creature who was being *led* into their perverted games. For most, this was the first time they had ever seen this aggressive, commanding, dominating, and controlling woman, subdued. This was their first opportunity to view Alex as I frequently saw her. A petite, agile, gorgeous and submissive creature, completely under my power.

I looked for the perfect location to place her. The room was crowded, and most of the bondage fixtures were occupied. However, I wasn't looking for a bondage piece. A blank wall where I would not interfere with any other scene would serve me well. This was not going to be my usual scene.

The Devil firmly placed her Bride against the wall, tucked the front of her skirt into her belt to keep her sex completely exposed, spread her legs, and placed a sign on the wall above her head. Turning to the Chauffeur from Hell, she told the driver to lace dental floss between the magnets which were on either side of Alex's clit, in effect sewing her lips closed.

I watched as she painstakingly and respectfully laced the threads over and around each magnet, like lacing shoes. With each tug Alex shuttered, legs buckling, fighting to remain upright, using the wall for support. When my helper finished, I stood back and admired my handiwork. The sign over her head read:

SATAN'S Bride
Enjoy her beauty
Get as close as you wish, but do not
touch her.
Talk about her, but do not talk to her.
This is an important test which she
must endure!
You may make it as difficult
as you desire.
If you wish to touch her,
MAKE A DEAL WITH THE DEVIL

As I reread the sign, I became aware that we were surrounded by many spectators. Alex was beautiful in her suffering. She was listening to every sound, every voice, searching for the comfort of my voice. Her reactions to sounds would cause her to turn her head in the direction of the sound, only to be disappointed and turn back again when she realized it wasn't the sound she wanted to hear.

Sometimes a strange noise would catch her attention, and I could see her trying to figure out what the sound was. I watched the look on her face. I saw the determination that she would make me proud of her this night and not give in to the effects of whatever torture might be in store for her. She was resolved to endure whatever would happen this evening, and to do so with the dignity befitting my slave.

Deciding to make standing a bit more difficult, the Devil attached a weight to the strings hanging from the laced magnets which held Alex's clit prisoner. With each slight movement, every quiver, every throb of her sex, the weight would swing, increasing the throbbing in her clit which would then make the weight swing more furiously, which would cause her clit to throb harder. Her focus divided, she would have to strain to remain still. The more she focused on remaining motionless the more her clit would take control and begin to spasm, and when she would cum, the throbbing would make the weight swing and she would lose control once again. The result being that her legs would buckle occasionally, visibly undermining her ability to remain composed. The spectacle was indeed pleasing.

I walked away from Alex and into the main room where scenes of every kind were underway. Moans, groans, and the sounds of straps and whips kissing naked flesh greeted my ears. Bound bodies struggled to free themselves; reddening bottoms presented themselves for the lash; onlookers adorned in an assortment of imaginative costumes, filled the arena that had been embellished for this bizarre celebration, the uniting of the Devil and his Bride. (In my fantasy anything was possible, and I decided this event was created just for me and my Bride.)

I entertained myself by watching various scenes and mingling with the guests around the room. I turned to see

a crowd of people gathered in the passageway where I had left my Bride. I wandered over to the edge of the group and looked over their shoulders to view the exhibit which took their attention. A man was standing inches in front of Alex, his hands on the wall behind her supporting his weight so he would not touch her while carefully and gently blowing on her neck and shoulders. She was writhing from the sensations. She was unable to defend herself, or remove herself from the assault. I looked at the faces of the spectators as they watched her reactions. I could see the envy, admiration and lust in their faces as this anonymous man continued his invasion into her space, her mind, and her essence. Her cringing, moaning, and panting inspired him to be more creative. His onslaught continued relentlessly.

I turned and watched my helpers, Death and the Chauffeur from Hell, who were handing out cards printed for this special event:

Make a DEAL
With the DEVIL
Good for one night only

The reactions were fascinating. Would they really be able to play with Alex? Dominate her? Would this be the one occasion I would allow them to touch her? What would they have to offer? Others, after reading the card, would shove it back at the helper like it burned their fingers. Some just smiled and envied. . . . Whom did they envy, me or her? This was a truly interesting drama being played out just for my pleasure. Looking back at Alex, I realized this man who was enjoying taunting and tormenting my Bride would be there all night, and I wanted more people to have access to

her. Moving him away, the Devil placed her hand on Alex's chest and pushed her back flat against the wall. She flinched with recognition of the familiar touch. Alex's bowed and cringing body once again regained composure. She had forgotten where she was as she was lost in the intensity of this simple but tormenting scene. After straightening her, the hand moved to the inside of her thigh, a reminder that she must keep her legs apart. She immediately obeyed, and once again was made painfully aware of the weight swinging from her clit. The buckling of her knees marked her awareness.

Standing was a strain for Alex at this point. I watched the struggle within her. It would have been easier to just slide down the wall and sit on the floor. No instructions had been made to the contrary, however, accomplishing this feat of standing where she was placed in obedience was necessary for her self esteem within this scene. The only thought that existed for her at that moment was to remain upright. Her body took on a tension that ran completely through her and into every extremity. That tension was spring-loaded. When released, it would propel her into an orgasm of immense proportions. I smiled because I knew the evening was only beginning.

The Devil then pulled the Bride away from the wall, allowing the tormenters to surround her. Each person around her had a different idea of torture: Words, breath, slaps of hands on hands near her ears. There was no sign any of them would tire of the game they were playing with her.

While she was thus occupied, I was making deals with various people for their participation in this amusement. The offers were fascinating: a massage, over my knee for a spanking, a caning Just what could they offer me?

Their slave, maybe? All they wanted to do was to touch her. They would give anything, *anything* just to use their fingers or feathers or fur mit to torture her. Little did they know that I was prepared to offer her for most anything—to be whipped, spanked, bound, tortured, just about anything—but they didn't ask. It was just too much too soon, and when some finally found their courage, it was too late. I had made all the deals I wanted. I had spanked, caned, whipped, and had commitments for many other things. Alex had lived the torments of the evening for several hours. Now it was time to conclude the festivities, and bring her back to me.

The Devil moved once again to her Bride, and brought her to her knees. She had been standing for a couple of hours, being tormented and tortured by those around her, and now one last deal was to be fulfilled. One person who had surrendered his prize possession to me, made a deal with me to spank my Bride, and now was the appropriate time.

Her bottom reached for the spanks. She welcomed them, and when the deal-maker was finished, I began. The harder I spanked, the louder her "thank-you's" became. She recognized that each slap was from a familiar hand. She began to climax, and her body began to thrash. I held her tightly. She remained on her knees as I released her bonds and unwrapped her head. When she finally opened her eyes, she registered shock at where she was, and the group of people surrounding us. She shook her head in disbelief, then closed her eyes once again to go back to the place where she had safely lived for the past three hours. She wasn't ready to return to reality. I held her. The party went on.

EPILOGUE

January 1994

I've attempted to give you "snapshots" of scenes, of emotions, of passions, of longings, along with the motivations that create and enhance them. I want to kindle your creativity and inspire your imagination for your own scenes. And, if you have not done so yet, I hope I have given you the courage to go for your dreams.

The S/M world of fantasy play is great. It has enhanced my life immensely for the past thirty years. I plan to continue my adventures, with the people I enjoy, for a very long time.

In going out to begin your adventures, remember there are several components that are necessary for a successful scene. The most important element—for both the bottom and the top—is trust. Without trust it's impossible to lose yourself in the scene. The next is communication. In whatever you do, communicate with your partner. Don't expect him or her to anticipate your needs without being told. We all have our own preferences. Some people who are into bondage vehemently dislike rope, but love chains. Others hate chains and swear by rope. Some people into flagellation only want to be whipped on their bottoms, and other people find their backs to be the place they can take the pain they need. Others who are into head-games, want

195

complete fantasy, while others need the games to be reality-based.

Nothing is wrong. It's only a matter of preferences.

Don't be afraid or ashamed of your fantasy. Don't be hesitant in explaining just what it is you need from the scene. As long as you do it in a safe, sane, consensual, and respectful manner, you and your partner will walk away from that scene fulfilled. It can be a wonderful adventure. It's a journey that can take you out of your present reality and deposit you in a delicious fantasy where your only reality is what you choose. It's up to you!

It's time for me to stop writing as I'm in the process of planning another party. I've invited fifteen great players to contribute again to the demise of the arrogant Alex. It seems no one tires of seeing her put in her place, and I love doing it. We all will have a great time experiencing the wonders of fantasy play in our own way.

I hope you will be doing the same.

Also available from Daedalus Publishing Company
www.daedaluspublishing.com

Painfully Obvious
An Irreverent & Unauthorized Manual for Leather/SM
Robert Davolt's new anthology takes an unorthodox look at leather relationships, community, contests, business, tradition, history and leadership. Inside perspective and practical tips on "What To Wear," "Leather On The Cheap" and "Passing The Bar," are delivered with authoritative research and barbed humor. **$16.95**

Spirit + Flesh
Fakir Musafar's Photo Book
After 50 years photographing Fakir Musafar's own body and the play of others, here is a deluxe retrospective collection of amazing images you'll find nowhere else... 296 oversize pages, three pounds worth! This book is a "must have" for all serious body modifiers, tattoo and piercing studios. **$49.50**

Urban Aboriginals
A Celebration of Leathersexuality – 20th Anniversary Edition
As relevant today as when it was written 20 years ago, author Geoff Mains takes an intimate view of the gay male leather community. Explore the spiritual, sexual, emotional, cultural and physiological aspects that make this "scene" one of the most prominent yet misunderstood subcultures in our society. **$15.95**

Carried Away
An s/M Romance
In david stein's first novel, steamy Leathersex is only the beginning when a cocky, jaded bottom and a once-burned Master come together for some no-strings bondage and s/M. Once the scene is over, a deeper hunger unexpectedly awakens, and they begin playing for much higher stakes. **$19.95**

Ties That Bind
The SM/Leather/Fetish Erotic Style
Issues, Commentaries and Advice
The early writings of well-known psychotherapist and respected member of the leather community Guy Baldwin have been compiled to create this SM classic. Second edition. **$16.95**

SlaveCraft
Roadmaps for Erotic Servitude Principles, Skills and Tools
Guy Baldwin, author of *Ties That Bind*, joins forces with a grateful slave to produce this gripping and personal account on the subject of consensual slavery. **$15.95**

The Master's Manual
A Handbook of Erotic Dominance
In this book, author Jack Rinella examines various aspects of erotic dominance, including s/M, safety, sex, erotic power, techniques and more. The author speaks in a clear, frank, and nonjudgmental way to anyone with an interest in the erotic Dominant/submissive dynamic. **$15.95**

The Compleat Slave
Creating and Living and Erotic Dominant/submissive Lifestyle
In this highly anticipated follow up to The Master's Manual, author Jack Rinella continues his in-depth exploration of Dominant/submissive relationships. **$15.95**

Learning the Ropes
A Basic Guide to Fun S/M Lovemaking
This book, by s/M expert Race Bannon, guides the reader through the basics of safe and fun s/M. Negative myths are dispelled and replaced with the truth about the kind of s/M erotic play that so many adults enjoy. **$12.95**

The Leather Contest Guide
A Handbook for Promoters, Contestants, Judges and Titleholders
International Mr. Leather and Mr. National Leather Association contest winner Guy Baldwin is the author of this truly complete guide to the leather contest. **$12.95**

Consensual Sadomasochism
How to Talk About It and How to Do It Safely
Authors William A. Henkin, Ph. D. and Sybil Holiday, CCHT combine their extensive professional credentials with deep personal experience in this unique examination of erotic consensual sadomasochism. Second edition. **$17.95**

Chainmale: 3SM
A Unique View of Leather Culture
Author Don Bastian brings his experiences to print with this fast paced account of one man's experience with his own sexuality and eventual involvement in a loving and successful three-way kink relationship. **$13.95**

Leathersex
A Guide for the Curious Outsider and the Serious Player
Written by renowned s/M author Joseph Bean, this book gives guidance to one popular style of erotic play which the author calls 'leathersex'- sexuality that may include s/M, bondage, role playing, sensual physical stimulation and fetish, to name just a few. Second edition. **$16.95**

Leathersex Q&A
Questions About Leathersex and the Leather Lifestyle Answered
In this interesting and informative book, author Joseph Bean answers a wide variety of questions about leathersex sexuality. Each response is written with the sensitivity and insight only someone with a vast amount of experience in this style of sexuality could provide. **$16.95**

Beneath The Skins
The New Spirit and Politics of the Kink Community
This book by Ivo Dominguez, Jr. examines the many issues facing the modern leather/SM/fetish community. This special community is coming of age, and this book helps to pave the way for all who are a part of it. **$12.95**

Leather and Latex Care
How to Keep Your Leather and Latex Looking Great
This concise book by Kelly J. Thibault gives the reader all they need to know to keep their leather and latex items in top shape. While clothing is the focus of this book, tips are also given to those using leather and latex items in their erotic play. This book is a must for anyone investing in leather or latex. **$10.95**

Between The Cracks
The Daedalus Anthology of Kinky Verse
Editor Gavin Dillard has collected the most exotic of the erotic of the poetic pantheon, from the fetishes of Edna St. Vincent Millay to the howling of Ginsberg, lest any further clues be lost *between the cracks*. **$18.95**

Ordering Information

By phone: 323.666.2121
By via email: order@DaedalusPublishing.com
By mail:

Daedalus Publishing Company
2140 Hyperion Ave
Los Angeles, CA 90027

Payment: All major credit cards are accepted. Via *email or regular mail*, indicate type of card, card number, expiration date, name of cardholder as shown on card, and billing address of the cardholder. Also include the mailing address where you wish your order to be sent. Orders via regular mail may include payment by money order or check, but may be held until the check clears. Make checks or money orders payable to "Daedalus Publishing Company." *Do not send cash.*

Tax and shipping California residents, add 8.25% sales tax to the total price of the books you are ordering. *All* orders should include a $4.25 shipping charge for the first book, plus $1.00 for each additional book added to the total of the order.

Since many of our publications deal with sexuality issues, please include a signed statement that you are at least 21 years of age with any order. Also include such a statement with any email order.